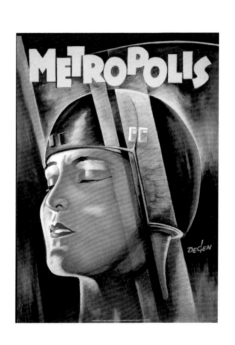

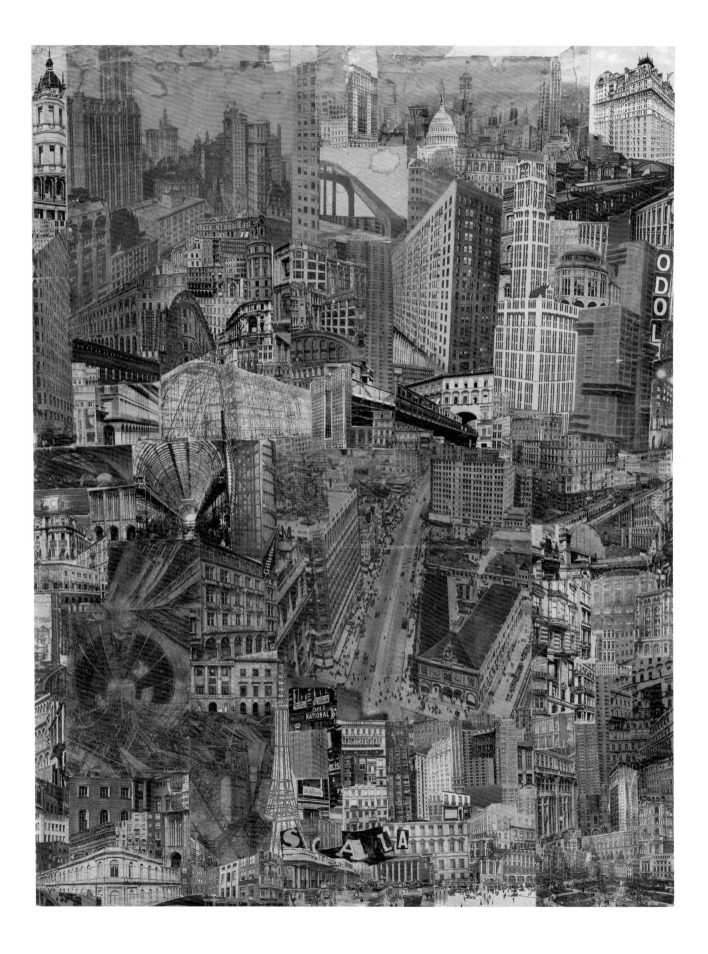

Rainer Metzger (ed.)
Ralf Burmeister
Maik Novotny
Ulrike Zitzlsperger

1920s Berlin

TASCHEN

Contents

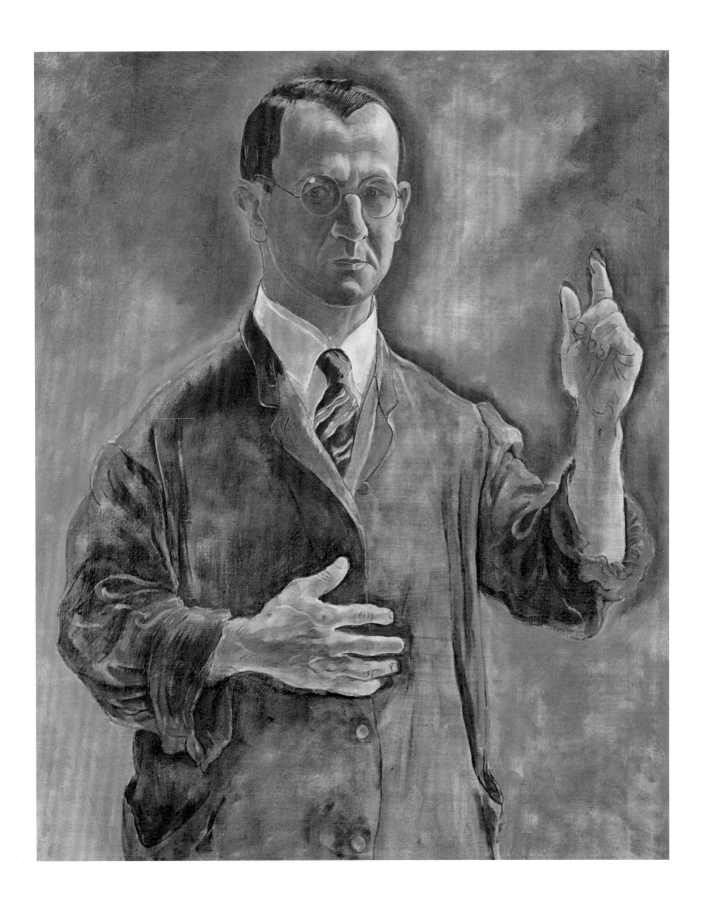

A Metropolis in the Making
Rainer Metzger

Berlin Street Scene (ill. p. 9) is full of hustle and bustle: Nikolaus Braun (1900–1950) offers an appropriate representation of the metropolis in his cityscape. Amidst the throng are people with figures and faces of all kinds: some smart and shiny, others shabby and lost in thought, and therefore oblivious to the traffic. A tram trundles towards us. It shares the street with a horse-drawn carriage – the lingering record of an earlier epoch – and an omnibus, which announces that Berlin now rhymes with engine. The architectural setting, meanwhile, resembles a theatrical backdrop: like an advent calendar on Christmas Eve, Braun's painting offers a colourful series of pictures-within-a-picture, all of them showing scenes typical of urban life. Men's and women's outfitters, shoe shops and hairdressers symbolize the avid desire to keep up with the latest fashions, as propagated by *Vogue* magazine, which appeared briefly at the end of the 1920s in a German edition. Translation services (*Übersetzung*) are offered, because the metropolis is multilingual. An antiquarian bookshop stands for the sterling value of a cultured education, a used-carpet showroom for the corresponding value of a smartly furnished home, and the two together represent the options for selling second-hand goods during hard times. That conditions and circumstances are currently not so good can be read in particular from the row of shops at street level. Although the butcher's is excellently stocked with its pork carcasses on hooks, flesh of a different kind is evoked in the prostheses on sale next door: the world war that has only recently ended has torn painful holes not just in the overall population but in the bodies of a great many individuals. Next door is the only commercial premises with its shutters down. The sign names it as the "Sportbank" – money is evidently all too short. On the far left, lastly, is the entrance to a theatre, where the performance is *Die Tanzgräfin*, an operetta by the composer Robert Stolz (1880–1975) from Vienna. The two capital cities of the main losers of the First World War both agree that visiting places of entertainment can help you to forget your troubles. *Die Tanzgräfin* celebrated its premiere in Berlin on 18 February 1921 – the same year in which Braun painted his *Berlin Street Scene*, which balances astonishment at all there is to see with the artistic achievements of the avant-garde. Then, in the midst of the commotion, a pause: a Madonna with a nimbus appears on the asphalt, as isolated as she is lost.

That Nikolaus Braun, member of the revolution-minded Novembergruppe of artists, should give religious connotations to an oasis of calm is typical in its strange disconnection from the times. A sense that things cannot carry on as they are surrounds even the loudest and most candid homages to the colourfulness, variety and otherness that characterize the culture of Berlin in its best years. In his diaries, Count Harry Kessler (1868–1937), diplomat, impresario, aesthete and member of the in-crowd, is a chronicler of events *par excellence*. On 9 February 1919, looking back over the three months exactly

Hans Hofmann
Franz Hessel: Spazieren in Berlin (Walking in Berlin: A Flaneur in the Capital), 1929
Book cover, 21 x 13 cm (8¼ x 5 in.)
Leipzig/Vienna, Publisher Dr. Hans Epstein

George Grosz
Self-Portrait as Warner, 1927
Oil on canvas, 98 x 79 cm (38½ x 31 in.)
Berlin, Berlinische Galerie, Landesmuseum für Moderne Kunst, Fotografie und Architektur

Friedrich Wilhelm Murnau
Nosferatu – A Symphony of Horror, 1922
Film still

since his city became the capital of a Republic, he uses the idiomatic phrase *Der Tanz auf dem Vulkan* – dancing on top of a volcano – as the most appropriate way to describe things so far.[1] Just as the author himself, for all his cosmopolitanism, still retains an aristocratic snobbery and the know-all manner of the traditional, so the image he evokes of a catastrophe waiting to happen remains thoroughly conventional.

This same premonition haunts one of the most incisive representatives of the press: Siegfried Kracauer (1889–1966), Berlin correspondent of the Weimar Republic's most important superregional newspaper, the *Frankfurter Zeitung*. In 1926, at the height of the Golden Twenties, when the hardships of the immediate post-war years seem to have been overcome and something resembling prosperity is emerging, Kracauer reflects upon the "cult of distraction," upon the inimitable way in which Berliners throw themselves headlong into pleasure, and upon how by tomorrow they will already be ditching today's trends and embracing the next ones. Among his descriptions, reflections and enthusiastic observations, however, he adds, by way of corollary: "In the streets of Berlin, one is regularly struck for moments at a time by the realization that everything will one day suddenly fall apart."[2] These premonitions are naturally justified. We can even put a specific date on Kracauer's "one day": it is 30 January 1933. The National Socialists come to power and only relinquish it when everything – houses, hearts and the entire concept of civilization – is not merely broken in two, but shattered into pieces.

In 1927 Walther Ruttmann (1887–1941) composed his *Sinfonie der Großstadt* (*Berlin: Symphony of a Great City*) in cinematic images (ill. pp. 4, 71). Divided into five acts, the silent film follows a single day in the life of Berlin, which is actor, setting and crime scene all in one. Once again, Berlin is pure hustle and bustle. The city's fast-paced, irresistible, in a word modern character can be read in the German title, in which the word *Sinfonie* is spelled with an *f* instead of the normal *ph* and thus in a non-academic manner, as it were without humanism. Five years previously Friedrich Wilhelm Murnau (1888–1931) had directed his showpiece horror movie *Nosferatu* (ill. p. 8). Its subtitle – in this case, properly spelled – was *Symphonie des Grauens* (*A Symphony of Horror*). The difference between these two productions is already a clear marker of the change that Berlin had undergone within the space of five years during the Roaring Twenties: horror, fear and trembling in the face of the inescapable has given way to suave, cool and blasé activity. Instead of exploring the unfathomable depths of the self and reality, it is now all about seeing and being seen in the competition for attention; instead – and these would be the terms coined by cultural history – of Expressionism, New Objectivity; instead of soulfulness, surface; instead of the volcano, just the dancing. But it will not be long before horror returns to the metropolis. The symphony to which it plays out is nationalistic, Aryan and barbaric.

Spazieren in Berlin (*Walking in Berlin: A Flaneur in the Capital*; ill. p. 7), which appeared in 1929, is one of the finest books on the zeitgeist of the Twenties. In it, Franz Hessel (1880–1941), by day a copy-editor for Rowohlt publishers, practises a pointedly relaxed form of locomotion. In opposition to speed, pressure and hype, he devotes himself to strolling, to aimlessly wandering around the city on foot. "Letting himself go" not in the notorious but in the literal sense, he allows his legs to carry him forward. Hessel's book, too, is overshadowed by the impending catastrophe. Hence his discovery of slowness is an adjuration. It is Hessel who proclaims the words *Wir werden Weltstadt!* ("We're becoming a metropolis!") cited in the title of this essay.[3] Let us just think about those three short, alliterative words and their exclamation mark for a moment. The *Wir* ("we") stands for a solidarity that is anyhow impossible to achieve in a disparate polity of more than four million people. The *werden* ("are becoming") points to the future and just as much to the determination motivating Berlin's growth. *Weltstadt* ("metropolis"), lastly, is the label intended to afford muddle-headedness a sort of embedding in the logic of civilization. And finally the exclamation mark: if there is a notation indicating irony anywhere, it is here.

Weltstadt: in 1930 an author by the name of Otto Zarek (1898–1958) published his book *Begierde. Roman einer Weltstadtjugend* ("Desire: Novel of a youth spent in the metropolis").

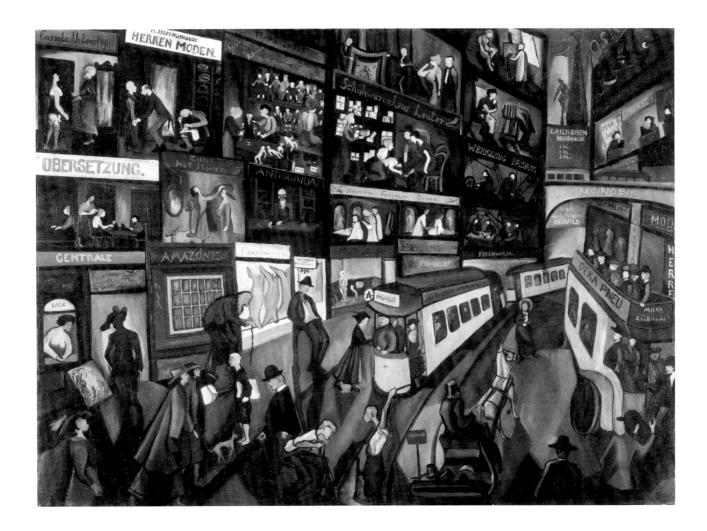

When Martin Wagner (1885–1957), who as chief city planner was responsible for the signatures of much of its modern architecture, wrote one year earlier about his policy of creating open spaces, he spoke of Berliners in terms of a mechanized metropolitan workforce that needed parks, swimming baths and open spaces as compensation. A "metropolitan square" was already taking shape on Alexanderplatz, an urban space repeatedly subject to redesign and long since part of literary history.

Berlin in the 1920s competes with none less than New York and Paris. The first of these – a parvenu and even more of a magnet for immigrants than Berlin – is just taking off. The second, a kind of personification of everything connected with good living, good style and good lifestyle, is the theatre of the avant-garde. As conspicuously signalled by its skyscrapers, New York is working its way up. Paris, with its tradition of being anti-bourgeois, provocative and in permanent revolution, is working its way down. Berlin is working its way outwards. This is true of its surface area, which expands more and more, above all from 1920, when the incorporation of formerly independent municipalities such as Charlottenburg and Schöneberg gives rise to a Greater Berlin. It is true of the attractions offered to the residents that are catering to ever-broader swathes of the public, as theatres, cinemas and places of entertainment overcome the ancient divide between the elite and the masses and become a form of popular culture. And it is true of those people who see, in Berlin especially, a unique chance to emancipate themselves from the shackles of convention; groups who, within the age-old divisions between aristocracy here and workers there, educated middle classes here and lower classes there, the Establishment here and the nouveaux riches there, have not thus far received proper recognition. They

Nikolaus Braun
Berlin Street Scene, 1921
Oil on hardboard, 74 x 103 cm
(29¼ x 40½ in.)
Berlin, Berlinische Galerie,
Landesmuseum für Moderne Kunst,
Fotografie und Architektur

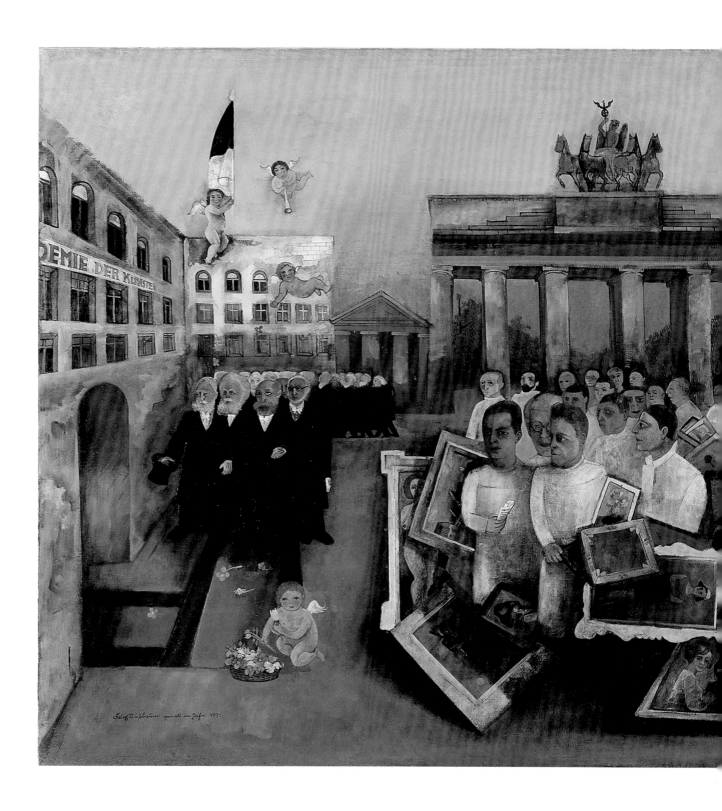

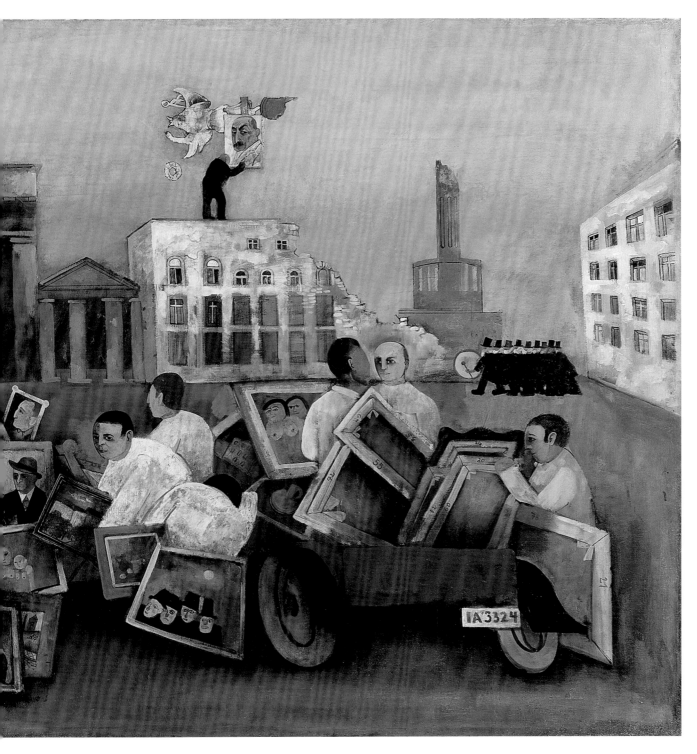

Felix Nussbaum
The Great Square, 1931
Oil on canvas, 97 x 195.5 cm (38¼ x 77 in.)
Berlin, Berlinische Galerie,
Landesmuseum für Moderne Kunst,
Fotografie und Architektur

are those whose demands for self-realization are once again being put forward in our own day: women and homosexuals.

When the openly left-wing film *Kuhle Wampe oder: Wem gehört die Welt?* (released in English as *Kuhle Wampe or Who Owns the World?*; ill. p. 21 top) was made in 1932, under the direction of Slatan Dudow (1903–1963) and with the collaboration of Bertolt Brecht (1898–1956), the demise of the Republic and its capital had long been in sight. The film's most famous sequence takes place on a train, which is returning people to the city from a workers' sporting event. The passengers get into a discussion about the current state of affairs with the economic crisis and horrendous unemployment. Some of them are satisfied with the way things are, while others want to see change, leading to the logical question: "Who will change the world?" The reply: "Those who don't like it." But herein lies the nub of the problem. Not only is there disagreement between those content with the status quo and those who want change, but there is also disagreement, among these latter, over their ideas of how that change should look. In the years up to 1933, Berlin became a metropolis above all because it allowed, effected and encouraged change as never before. The change that came out of it all at the end, however, defied all logic.

Other times

Past, present and future meet in a strange conjunction in *The Great Square* (ill. pp. 10–11) by Felix Nussbaum (1904–1944). Solemn figures in the old-fashioned black-and-white style of dress are advancing, as if a stream, from the left, i.e. from the side where, according to the conventional direction of reading, we find the "once-upon-a-time" beginning, set in the past. The procession is heading for the Academy of Arts, the Olympus to which these figures were once raised on the basis of their services to Beauty in literature, art and music. A few putti flutter around them with the trappings of their fame. In the centre of the painting, the present day: younger men, evidently all painters, are holding pictures – portraits, still lifes and nudes. They seem to be presenting themselves before the immortals, whose ranks they themselves one day wish to join. Nussbaum, who was just 27 years old when he executed this painting in 1931, will have meant himself among the parade of the excluded. On the right, lastly, lies the future – and it looks gloomy. The great square (in Nussbaum's German title, *Der tolle Platz*, the adjective *tolle* means "great" in the sense of "awesome" or "amazing") is Pariser Platz, Berlin's most prestigious address. The splendid buildings lining the square, with the Brandenburg Gate at their centre, have been partially destroyed. In particular the mansion next to the Gate, home to Berlin's most famous artist, lies in ruins. The Victory Column, which at that time stood beside the Reichstag, is likewise reduced to a forlorn stump. However sensational an image the Twenties liked to project, Berlin's best-known artist is still Max Liebermann (1847–1935; ill. p. 13). The Impressionist, representative of the 19th century and figurehead of a moderate modernism had been obliged to endure the Kaiser, when there still was one, dismiss as "gutter art" his painting of air and light. Yet overall its inviting brightness fit perfectly into the social aspirations of the bourgeoisie. Liebermann – we can see his portrait hovering above the flat roof of his mansion, accompanied by the goddess Victoria fallen from her plinth – came from a Jewish family. So did Nussbaum. A pall of nothing less than tragic destiny thus hangs over his sombre cityscape.

Liebermann, the Impressionist, was above all also a Secessionist. In the glorious avant-gardism of the years before the First World War, Secessions seemed like a guarantee of change. They assumed an institutional air and were thereby influential exclusively within artistic circles. By means of Secessions – breakaway organizations – a clique of painters, sculptors and applied artists declared themselves dissatisfied with the current state of artistic affairs, for which the upstarts and the old hands were naturally to blame. Such was the rapid pace of developments that cliques had no sooner emphatically embraced the New than they became the embodiment of the Old and were supplanted in their turn. In Berlin, this meant that the Secession founded in 1898 in opposition to the Künstlergenossenschaft association of artists was obliged to see a New Secession break

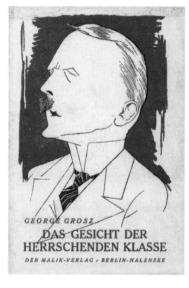

George Grosz
Das Gesicht der herrschenden Klasse
(***Face of the Ruling Class***), 1921
Cover design, cardboard with
title drawing in black and red,
25.2 x 17 cm (10 x 6¾ in.)
Berlin, Malik-Verlag

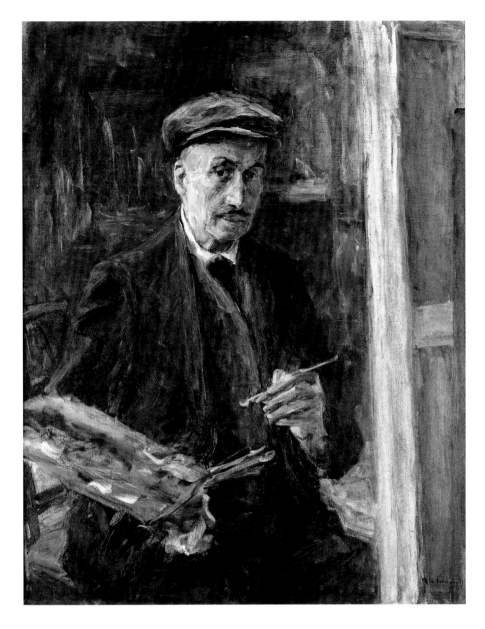

Max Liebermann
***Self-Portrait with Sports Cap
at the Easel***, 1925
Oil on canvas, 112 x 89 cm (44 x 35 in.)
Staatliche Museen zu Berlin –
Preussischer Kulturbesitz, Nationalgalerie

away from it in 1910, followed in turn by a Free Secession in 1914 – to say nothing
of the shock-troops of the contemporary vanguard, such as the group Die Brücke ("The
Bridge") constituted in 1905 and the host of internationalists whom the gallerist Herwarth
Walden (1878–1941) tossed into the mix under the telling name Der Sturm ("The Storm").
Significantly, when the new, the revolutionary and the irresistible shifted from art to the
city and the nation, all obduracy and insistence on holding an exclusive mandate came to
an end. At all events, the Novembergruppe, which took its name from the German Revo-
lution of 9 November 1918 and which subscribed, with its various artistic programmes,
to the political aims of the Left, was joined by members of all the Secessions.

Kurt Tucholsky (1890–1935), another example of the typical Berlin combination of
newspaper journalist and literary figure in one person, looks back at those November
days in his 1929 poem *Ideal und Wirklichkeit* ("Ideal and Reality"). The lyrics of the verse
can loosely be translated as: "You want to buy a pale-coloured pipe / and buy the dark
one – there are no others. You want to go jogging every morning / and don't. Almost…
almost… / Under imperial constraint we thought / of a Republic and now it's this one! /

You always want a tall thin one and then you get a short fat one – / selavy."[4] (*C'est la vie.*) This life furnished the young German democracy with every conceivable difficulty: unconditional capitulation in a war whose front lay hundreds of miles beyond the country's own borders; conspiracy theories correspondingly rampant right from the start; unmanageable reparation payments; inflation deliberately triggered in order to avoid these payments; a brief phase of hope as the new money and the new attractiveness of the capital acted as a global magnet; from 1929 the great economic crisis delivering another blow to the stricken country; and lastly the revival of the political radicalization that had fuelled the disastrous chain of events from the beginning.

From the beginning. It started with the fact that, on 9 November 1918, the Republic was proclaimed in Berlin not once but twice: firstly by the Social Democrat Philipp Scheidemann (1865–1939), who declared a parliamentary version from the Reichstag, and secondly by Karl Liebknecht (1871–1919), chief agitator of the newly founded Communist Party of Germany, who announced a Free Socialist Republic from the balcony of the former imperial palace. While Scheidemann told people to remain calm, Liebknecht exhorted the public to arm themselves with the weapons left over from the world war. The Republic that was subsequently created was named after Weimar, where the assembly had relocated in order to draw up the constitution – the situation in Berlin being considered too unstable – and was of the Scheidemann kind. To this end, it had to clear the one envisaged by Liebknecht out of the way. The anti-Republicans of the right – monarchists, chauvinists and militarists – helped it do so. No wonder many representatives of the cultural sphere, such as Tucholsky, grew disenchanted with it. Throughout the barely 15 years of the Weimar Republic, Berlin itself remained left of centre. In the municipal elections of October 1921, for example, almost 50 per cent of the vote went to the parties of the left; in April 1932, when the signs were already pointing to what we know now, the Social Democratic Party and Communist Party secured an absolute majority in the elections for the Prussian state parliament in Berlin, while the National Socialist German Workers' Party – the Nazis – received just 28 per cent of the vote.

However appalling for everyone the political changes that followed the end of the German Empire, the arts at first clung resolutely to the pre-war period. The aesthetic programme was focused on Expressionism, with its piling up and ramping up and its high pitch of authenticity and soul-baring, which had broken new ground around 1910. Thus Berlin poet Johannes R. Becher (1891–1958), later known for authoring the lyrics of the German Democratic Republic's national anthem, composed a hymn in 1921 that can be loosely translated as: "Tell me O brother my person who are you?! / Flawless constellation of stars in the heaven-wish of the poorest above. / Cruel fire-wound cool balsam-friend – / Magically sweet dew on tiger-wild thorny briar – / Gentle Jerusalem fanatical crusades – / Never-extinguishing hope."[5] Its title, stating the obvious, is *Der Mensch steht auf!* ("Man Arises!"). "Fire-wound" and "fanatical crusades": avant-garde is a military term. This vanguard deliberately took up violence and carried it into the artistic battlefield. The shock-troops were not impressed by the great slaughter; they understood war all too swiftly as aesthetics with different means.

In the years around 1925, this changed – as illustrated by Tucholsky's *Ideal und Wirklichkeit*, for example. The experience of the metropolis is a key influence. The form of expression becomes urbane, jargon retreats, the attitude is ironic and the corresponding mentality is cosmopolitan. Getting hot under the collar is out, coolness is in. The term for all this is supplied by an exhibition staged in 1925 at the Mannheim Kunsthalle, in the heart of the provinces that were now at last taking the capital as their model: Neue Sachlichkeit (New Objectivity) presents what has taken place in the way of smoothing out in the pictures of Otto Dix (1891–1969; ill. pp. 24, 65, 73, 74–75), George Grosz (1893–1959; ill. pp. 6, 41, 63), Christian Schad (1894–1982; ill. pp. 31, 79), Rudolf Schlichter (1890–1955) and numerous other painters.

Art critic Franz Roh (1890–1965) published a list of terms in which he distinguished the "Expressionism" that had existed to date from the "Post-Expressionism" by which

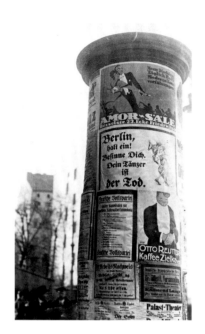

Berlin halt ein! Besinne dich. Dein Tänzer ist der Tod (*Berlin, stop! Come to your senses! Your dance partner is death*), 1919
Advertising column with poster warning the public against Berlin's prevailing hedonism
Lines taken from the song "Fox Macabre" by Friedrich Hollaender

Heinz Lienek
View of Friedrichstrasse / corner of Jägerstrasse from the U-Bahn entrance by night, 1926

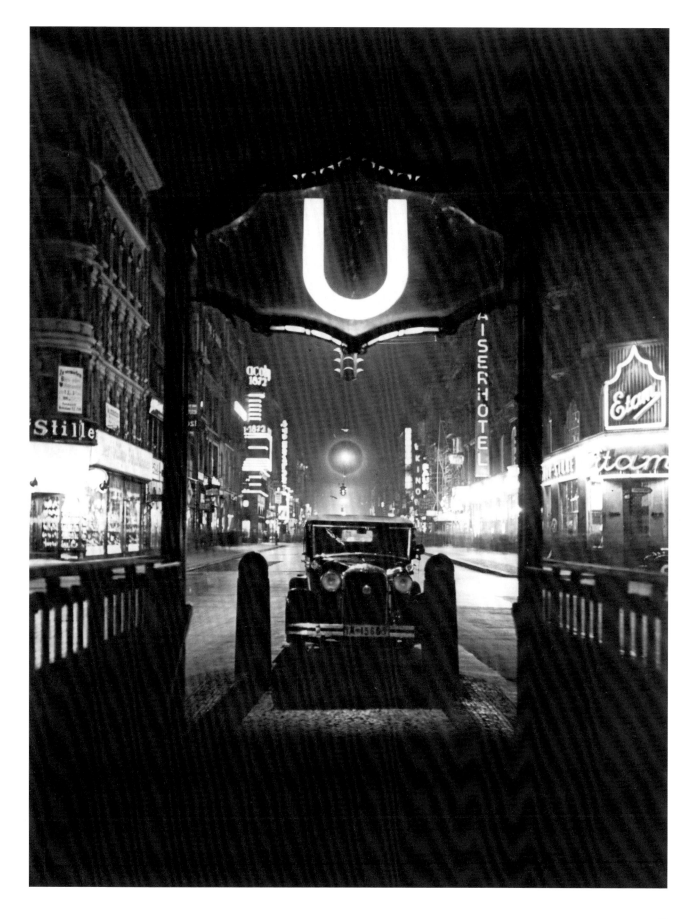

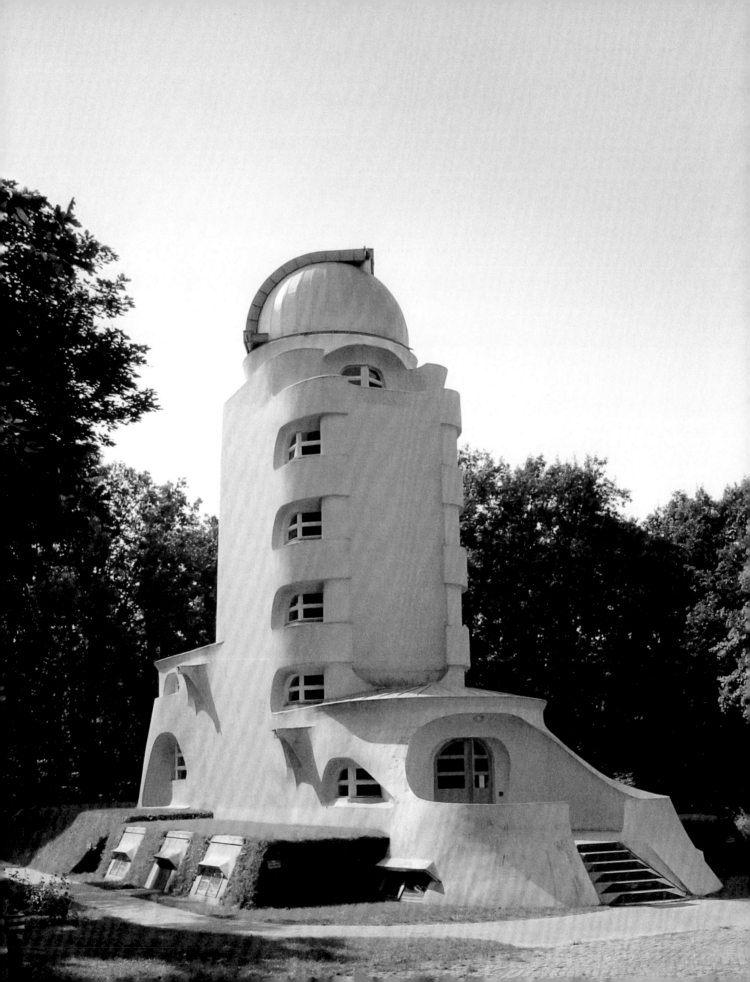

it was now being succeeded. Roh begins his catalogue with the observation that "ecstatic objects" have given way to "sober objects." The focus is now upon "representational" instead of "rhythmic," upon "deepening" instead of "exciting." Here are more of Roh's pairs of opposites: "excessive – more disciplined, purist"; "dynamic – static"; "monumental – miniature-like"; "roughening – smoothing, scumbled"; "like unhewn stone – like burnished metal"; "expressive deformation – harmonious purification"; and lastly "natural – cultivated."[6] Roh applied his pairs of opposites solely to painting. But the polarity of naturalness and cultivation, for example, serves equally well to characterize what is happening in art and culture as a whole. The city is appropriating the countryside.

Other places

Chaos and cosmos: *Metropolis* (ill. p. 2) is how Paul Citroen (1896–1983), born in Berlin as the son of Dutch parents with Jewish roots, titles his attempt to lend a logic to the disorder. In Ancient Greece, the metropolis was the mother-city, which propagated itself in the colonies founded on the other side of the sea. Berlin has often been described as the perfect colonial city: located far away to the East in the sands of the Margraviate of Brandenburg, it has not been nurtured and cultivated by settlers, soldiers and adventurers. The metropolis designed by Citroen in 1923 is a web of buildings. Photographs form the fabric of which the collage is constructed. Little of Berlin itself is recognizable. Instead we catch glimpses of New York, for example the world-famous rounded corner of the Flatiron Building in the top left, and an iron structure that closely resembles the Eiffel Tower in Paris. We see overhead railways and skyscrapers, a staccato of the kind drummed out by every modern city. Everything looms towards us at once. The multitude of visual impressions reaching us simultaneously leads to a feeling of spatial disorientation, dizziness and confusion. And yet this strangeness and alienation takes place on the surface of a sheet of paper.

How do you capture, pictorially and artistically, something whose variety and vitality cannot be contained? Berlin's most famous piece of literature also tries to achieve this using the technique of collage. For his definitive metropolis novel *Berlin Alexanderplatz*, (ill. p. 85) written in 1927/28, Alfred Döblin (1878–1957) combines all sorts of printed sources in his crafting of the book. He studies tram maps: the "Elektrische Nr. 68," for example, is followed stop by stop and its route appears in the text as a succession of street, square and avenue names. The AEG – along with Siemens, Berlin's chief electricity company – is looked up in the phone directory and listed by divisions, factories and departments. Sometimes Döblin simply cuts out newspaper articles and glues them into the manuscript. The typesetter is thus spared the task of deciphering his handwriting, and the aim of the aesthetic exercise – to strike a balance between the story of an individual and anonymous design – is underscored. "Literature," Döblin records, "adds something to the reality given by the material of our everyday words; the data of reality are used to show the fact that one adds and where one adds and what one adds. In the novel, this means layering, peeling, flattening, shifting."[7] The city in its jumbled mixture is taken apart and dissected. Its interstices are explored in order to find a place for the millions of unique lives that populate it. Franz Biberkopf, Döblin's hero, became a figure of world literature precisely on account of his niche existence in the crowd.

The *Metropolis* that springs to mind when we think of the 1920s is less a collage than a great, or at least a large-scale, work of cinema. The film (ill. pp. 1, 69) came out in 1927, but it appeared too late and signified the end of Berlin's ambitions to rival Hollywood. *Metropolis* was a monumental flop. Thousands of extras and vast sets were deployed for an alternative universe born out of the spirit of Expressionism. A city is conjured up – here, too, more New York than Berlin in its high-rise architecture. A strict hierarchy separates the elite from the proletariat, the luxury of the ivory tower from the misery of the underworld. In its eccentricity, exuberance and reactionary prophecies of a saviour, the film – directed by Fritz Lang (1890–1976) with a screenplay by his wife Thea von Harbou (1888–1954) – failed to match up to life in contemporary Berlin. It sought to present

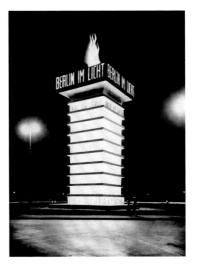

Unknown photographer
Berlin im Licht album, 1928
Gelatin silver print, 23.3 x 17 cm
(9¼ x 6¾ in.)
Stadtmuseum Berlin

Erich Mendelsohn
Einstein Tower, 1918–1924
Potsdam
View from the southeast

images to one of the watchwords of the day: the masses. But the masses, like a machine, continued all too dully in their relentless daily round. That these masses have their parallels in individuals, that they pursue visions of happiness and at the very least demand entertainment – to this, Berlin's main creed, *Metropolis* paid no heed. The film neglected to illustrate this creed in its plot. The masses are not individualized but they are shown on screen as part of a spectacle-loving society.

To survey other spaces in the Berlin of the 1920s means first and foremost seeking out the many places of entertainment, pleasure and distraction. On Friedrichstrasse, one temple of entertainment follows another: the Grosse Schauspielhaus theatre under its impresario Erik Charell (1894–1974), the Komische Oper with James Klein (1883–1943) as director, and the Admiralspalast, which Herman Haller (1871–1943) sought to fill every day. All over the city, and with a particular concentration in the splendid district around the Kurfürstendamm, there were huge movie theatres, premiere cinemas with several thousand seats. Sprinkled between them were dance halls and establishments for the more physical human needs. Wind direction dictated the level of luxury: in the west, where the air is fresher, everything was more glittering, more exquisite and more expensive, while in Berlin's "East End," also the setting for Döblin's *Alexanderplatz* novel, prices were a little more reasonable. All these spaces are characterized by the fact that they embed the quest for a little happiness within a broader general need and enrich individuality with anonymity. They thus supply the citizens with the elixir that binds them magically to this place: Berlin would not have boulevards without backstreets, would not be

The Threepenny Opera, 1928
Premiere of the play by Bertolt Brecht at the Theater am Schiffbauerdamm, Berlin

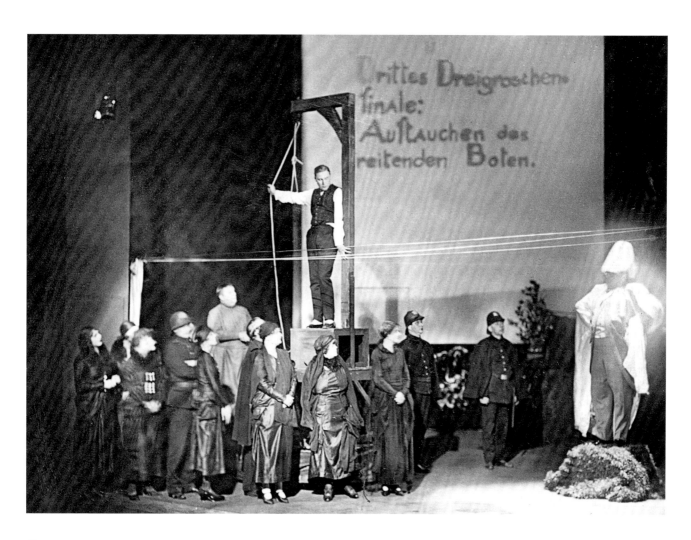

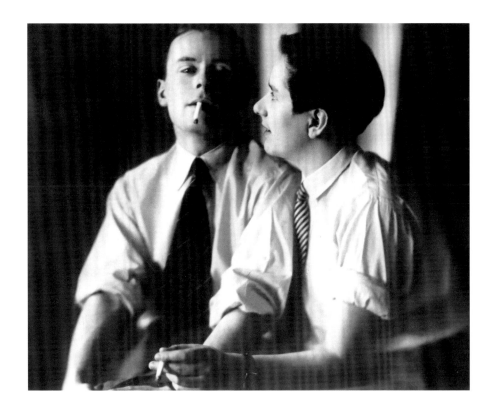

Lotte Jacobi
Klaus and Erika Mann, 1930
© The Lotte Jacobi Collection,
The University of New Hampshire

a metropolis without local colour, would not be civilization without neighbourhoods. This is true for all major centres: current needs to be earthed.

That this interaction with all its sunny and shadowy sides could take place in the Berlin of these years is directly linked with new technologies. Radio, for example, brought the world into German homes – initially only to a limited few, until the radio tower inaugurated in 1926 quite literally widened the reach of broadcasting (ill. p. 49). Electricity, too, arrived with a flash and a bang, as a warning sign, a triumph of artificiality, appearing out of the blue and bringing its own brilliance and shadowiness to the city. In October 1928 Berlin held a Festival of Light (ill. p. 17) that for a few days bathed its squares, streets and façades in illumination. It was a promotional event by businesses and the authorities – a public marketing exercise, so to speak, demonstrating state-of-the-art blurring on a grand scale: how individual houses could be absorbed into an ensemble, ensembles into bright lights, and bright lights into crystalline forms; how the city, in other words, might dissolve into the very thing it was advertising. This interplay between clarity and diffusion could be metaphorically extended to the passers-by in their uniqueness and their unapproachableness.

At the end of his book *Berlin – ein Stadtschicksal* ("Berlin – The Fate of a City"), published in 1910, critic and publicist Karl Scheffler (1869–1951) offers an observation about the city that has been quoted regularly ever since. Berlin, he concludes, is "damned forever to becoming and never to being."[8] It is a trite thing to say and can be applied to anything in a state of change. What is significant, however, is that two decades later, in 1931, Scheffler wrote another book that he now titled *Berlin – Wandlungen einer Stadt* ("Berlin – Changes of a City"). The author naturally investigates the new era and comes to the following conclusion, in which the mechanism of Berlin's light and dark sides is perfectly reflected: "Mass and quantity triumph there; but light spiritualizes and transfigures all that is material: it creates a feast for the eyes like no era before… This is the afterwork apotheosis of the metropolis, the victory song that the new Berlin sings to itself over and over again."[9]

Hans Baluschek
City Lights, 1931
Oil on canvas, 125 x 170 cm
(49¼ x 67 in.)
Stadtmuseum Berlin

"There are some who are in darkness / And the others are in light / And you see
the ones in brightness / Those in darkness drop from sight."[10] Thus runs the final verse
of "The Ballad of Mack the Knife" from *The Threepenny Opera*, written by Bertolt Brecht
with music by Kurt Weill (1900–1950), which rose to global fame in 1928 (ill. p. 18). The
moral of light and darkness was in fact a later addition: the verse was written in 1930
as part of plans to turn the play into a film. In 1931 Georg Wilhelm Pabst (1885–1967)
made the first film version, since when the verse has been an integral part of every pro-
duction. In Brecht's treatment of the English *Beggar's Opera*, the sinister voyage though
the underworld also becomes a description of life on and in front of the big screen.
Brecht's quatrain becomes a kind of self-reflection on the part of cinematography. Berlin's
metropolis culture is driven not least by this vision: the dream of one day exchanging
a life in darkness with one in the light.

Other people
The Wilke Siblings (ill. p. 21): Lotte and Ulfert Wilke are twenty and nineteen years old
respectively when Willy Jaeckel (1888–1944) paints their portrait in 1926. They are study-
ing under him at the Staatliche Kunstschule in Berlin. Their father Rudolf Wilke (1873–
1908), who died in their infancy, was a well-known illustrator. The resemblance between
the two is due not just to the fact they are sister and brother, but also to the fashion of the
day. Thus the young man's hair is relatively long, the woman's correspondingly short –
not quite the bob that is all the rage, but a cut that perceptibly reduces the visual distinc-
tion between the sexes. Such things, as cultural history knows, are characteristic of peace-
time: when men are permitted to do something other than fight each other, when what
counts is no longer militancy but taste, sophistication and refinement, they orient them-
selves towards women, who in turn meet them halfway in terms of hairstyle and dress.
When cities place their stamp upon peacetime, it is often fairly androgynous. There is
languidity rather than excitement, live-and-let-live acceptance rather than lurking ill-
will, indifference rather than difference. Hence a certain ennui and aloofness informs the
faces and poses of the two siblings. They parade as the youth of the metropolis. Both were
educated at the progressive Odenwaldschule private boarding school, where their fellow

pupils included Klaus Mann (1906–1949), the son of Thomas Mann (1875–1955), winner of the Nobel Prize for Literature. Klaus, himself a writer, and his sister Erika (1905–1969) appear in a comparable image referencing the theme of gender interchangeability: a picture taken by Berlin photographer Lotte Jacobi (1896–1990; ill. p. 19), an important portraitist of the zeitgeist. Indeed, the documentation of such trends becomes the specialist domain of women.

There have always been young people, but the idea that they might have their own value is entirely new. Youth has cast off the obligation to work its way up to authority and wilfully to age, as it were. Youth is now perceived as an independent quality, and proclaims itself via the obvious: it is called beauty. It is the preferred theme of films of the late 1920s, such as *Menschen am Sonntag* (English title: *People on Sunday*; ill. p. 29). Released in 1930, the silent film is an exemplary document of Berlin popular culture, on which later Hollywood greats such as Robert Siodmak (1900–1973), Billy Wilder (1906–2002) and Fred Zinnemann (1907–1997) cut their teeth. The camera follows five young people – a film extra, a model, a sales rep, a taxi driver and a record seller – who play themselves doing what they do: sleeping, swimming and working. The dream of every future model to make it big with their natural good looks fills the screen. The hairstyles lend the actors a particular attractiveness. In their combination of wearability, highlighting of individual shape and adaptation to the play with gender roles, they have perhaps never been more stunning than in these years.

Such popular culture was viewed from elite quarters, too, with something like pride – as voiced by Count Kessler, for example, in this very same year of 1930. In his diary, he records a conversation with the French sculptor Aristide Maillol (1861–1944), who was visiting him at the time, in which Kessler is clearly eager to convey the modern thinking reflected in the youthful bodies in the swimming pool. "I explained to him that this is indicative of only a part of a new vitality, a fresh outlook on life, which since the war has successfully come to the fore. People want to really live in the sense of enjoying light, the sun, happiness, and the health of their bodies. It is not restricted to a small and exclusive circle, but is a mass movement which has stirred all of German youth. Another expression of this new feeling for life is the new architecture and the new domestic way of living."[11]

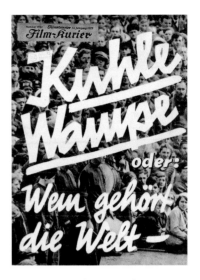

Kuhle Wampe oder: Wem gehört die Welt? (*Kuhle Wampe or Who Owns the World?*), 1932
Front cover of *Illustrierter Film-Kurier* no. 1751, issue about the film
Paper, 29.2 x 22.8 cm (11½ x 9 in.)
Berlin, Deutsches Historisches Museum

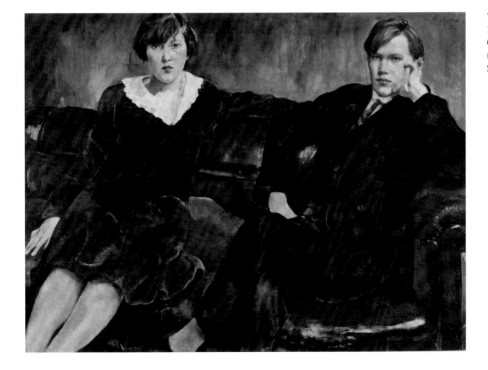

Willy Jaeckel
The Wilke Siblings, 1926
Oil on canvas, 110 x 150.5 cm
(43¼ x 59¼ in.)
Stadtmuseum Berlin

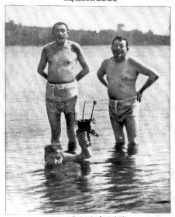

Wilhelm Steffen
Ebert und Noske in der Sommerfrische
(**Ebert and Noske at the seaside**), 1919
Front cover of *Berliner Illustrirte Zeitung*
no. 34, 24 August 1919

It is a classic, positively Ancient Greek belief that beautiful people give cause for optimism. As we know, this belief will prove a lie. But optimism needed to be built up, for the otherness paraded on the streets after 1918 was initially marked by its opposite: by people who were hideously injured and spoiled. People who had been shot on the battlefield and were now designated pitilessly but accurately by the word *Kriegskrüppel* ("war cripple"). The Berlin pacifist Ernst Friedrich (1894–1967) created a devastating memorial to them in an anthology of photographs published in 1924 under the title *Krieg dem Kriege* ("War against War"), which after a short introduction leaves the portraits of the disfigured to speak for themselves. These war veterans were figures of an Expressionist type, witnesses for the prosecution and rallying cries for a better world. Otto Dix devoted a major part of his œuvre to them in the early years of the Weimar Republic: *The Match Seller* (ill. p. 24), *Prager Strasse* and *War Cripples* were produced in Dresden; such unwilling players in a symphony of horror were not limited to Berlin.

Otto Dix made types out of contemporaries. George Grosz, his equivalent in a history of the painting of the 1920s, made contemporaries out of types. Both helped themselves liberally from the arsenal of caricature. While Dix primarily committed himself to portraying the maimed, Grosz found his witnesses for the ugliness of the day among functionaries, manufacturers, clerics and lawyers – the *Face of the Ruling Class* (*Das Gesicht der herrschenden Klasse*) that aroused false hopes of salvation in antiquated systems (ill. p. 12). Politicians as a whole now enter the social field. Whereas previously they had been notables, stooges of the timelessness for which the monarchy had stood, they now had to take centre stage. A photograph taken in summer 1919 did the rounds: it shows President Friedrich Ebert (1871–1925) and Minister of Defence Gustav Noske (1868–1946) at the seaside (ill. p. 22). The grotesque image of the two most senior representatives of the German nation in their bathing suits, all dignity gone, was gleefully reproduced in the national press and became the pin-up of an alternative world, if not an underworld.

Politics was suddenly a swindle on a grand scale. Politicians were corrupt, were cowards, were agitators, and when things grew really unstable, became victims of assassination, like Finance Minister Matthias Erzberger (1875–1921) and Foreign Minister Walther Rathenau (1867–1922). There was one, just one representative of the state who was considered reputable: Gustav Stresemann (1878–1929) stands in many respects for the better years of the Weimar Republic; his – natural – death in October 1929 signalled the beginning of the end. Berlin, for its part, could offer one impressive figure: Gustav Böss (1873–1946), the city's mayor since 1921. But he was embroiled in a corruption scandal: a minor affair, involving the gift of a fur coat to his wife, forced him to resign just one month after Stresemann's death.

There was a specialist for embarrassing moments: Berlin photographer Erich Salomon (1886–1944) captured Reichstag deputies on camera as they were eating, yawning and generally looking bored (ill. p. 25). He gave the public its politicians as celebrities and focused on what makes for good gossip: *Berühmte Zeitgenossen in unbewachten Augenblicken* (*Famous Contemporaries in Unguarded Moments*) is the title of his 1931 anthology of photographs. Here we see another facet of Berlin mass culture: what matters is who can turn the economy of attention to their advantage.

Those who personify novelty become stars: in the cinema and on the stage, as social climbers, nouveaux riches or one-day sensations on Berlin's AVUS section of motorway, opened in 1921. But also as highly esteemed individuals with a global reputation: Albert Einstein (1879–1955) lived in the city from 1914 until the end of 1932 and was fêted, showered with honours and booked for pacifist appearances. Naturally, no one in the culture of spectacle had any idea what his scientific teachings meant. Thus the most enduring thing associated with him in Berlin is an observatory, appropriately called the Einstein Tower (ill. p. 16), designed by modernist architect Erich Mendelsohn (1887–1953) and inaugurated in 1925. A telescope in the observatory was intended to verify Einstein's theories once and for all, but was unable to do so. The elegant aerodynamic lines of the

observatory nevertheless went down in art and architectural history, even if they failed to contribute to the advance of physics.

"People chide the Berliners for being addicted to distraction," notes Siegfried Kracauer in 1926, in his wonderful text *Kult der Zerstreuung* ("Cult of Distraction"): "The accusation is petty. Certainly, the addiction to distraction is greater here than in the provinces, but the strain upon the working masses is also greater and more palpable – an essentially formal strain that fills up the day without filling it. People want to make up for what they've missed; they can only do so in the same outside sphere of which, under duress, they have deprived themselves. The form of activity [German *Betrieb*] necessarily corresponds to that of their 'activity' [German *Betrieb*]."[12] With his pun on the German word *Betrieb* (whose many meanings include business, undertaking, enterprise, company, factory and operation), Kracauer reminds us that business is everywhere in Berlin (ill. p. 20) – whether as a business in which people work, or as the entertainment business. The fact that one is connected to the other is due to the energy of the "working masses." Many of them have sedentary jobs. Their workload is more about mental strain than physical exhaustion. They embody a new professional group, a new social class, a new political variable: they are employees. They flood into and out of offices, stream into the long-since-electrified vehicles of public transport and in the evenings billow with

Erich Heckel
Bathers II, 1919
Right-hand panel (female nude)
of the *Bathers* triptych
Tempera on canvas,
96.5 x 83 cm (38 x 32¾ in.)
Kunstsammlungen Chemnitz

expectations that are channelled by the many establishments. The employees have resources for these evenings: financial resources, because they earn more than the minimum wage; physical resources, because after sitting at their desks all day they want nothing more than to move; and psychological resources, for who knows for how much longer this good life will continue? Berlin's open industrial secret is its employees. They lend this great epoch its face.

Other morals

"Berlin, halt ein, besinne dich, dein Tänzer ist der Tod" ("Berlin, stop! Come to your senses! Your dance partner is death"): thus runs the central line in "Fox Macabre", a song written in 1920 by Friedrich Hollaender (1896–1976), the composer who ten years later would have Marlene Dietrich (1901–1992) "Falling in Love Again." The words were also the slogan of a poster that splashed a Dance-of-Death message across the city's advertising columns (ill. p. 14). In 1925 Otto Dix captured the face of this mood in his portrait of Anita Berber (1899–1928; ill. p. 27). She had primed the immediate post-war period with the notoriety of her naked performances. At a time when everyone had quite literally lost

Otto Dix
The Match Seller, 1920
Oil and collage on canvas,
141.5 x 166 cm (55¾ x 65¼ in.)
Staatsgalerie Stuttgart

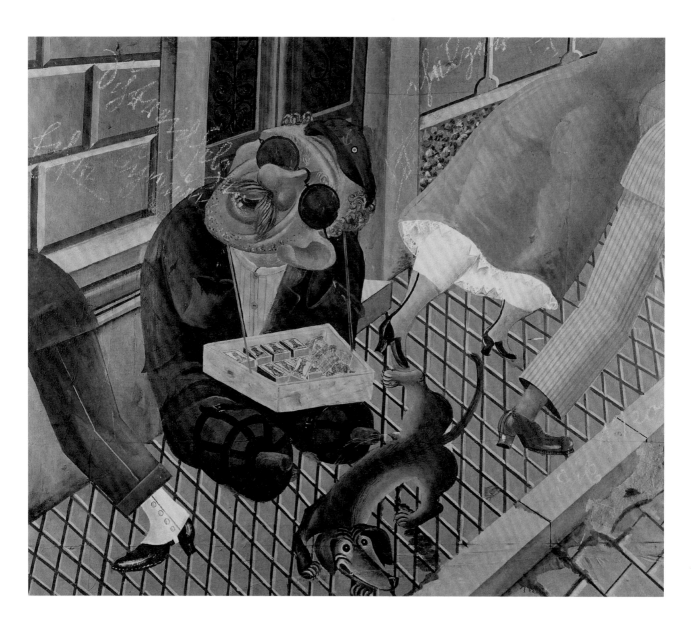

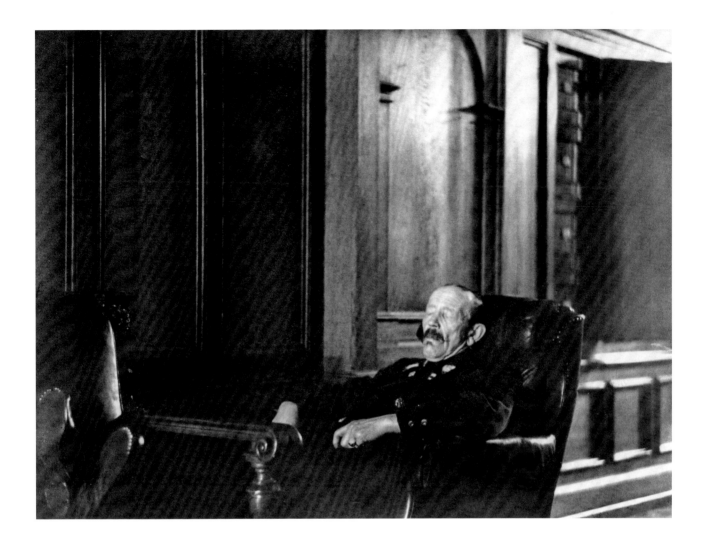

Erich Salomon
*Deputy Georg Eisenberger
in the Deputies' Lounge in the
Berlin Reichstag*, 1929
Berlin, Berlinische Galerie,
Landesmuseum für Moderne Kunst,
Fotografie und Architektur

the shirt off their backs, nude dancing was all the rage. Five years on, Dix considered it wholly unnecessary to take fresh outrage at such things. He portrays her very much clothed, tightly sheathed in the eye-catching red of a silk dress. And sheathed, too, in death. For everything in this face is poisonous: the eyes glitter as if from the underworld, the hair blazes in scarlet, and the skin is coated with the unapproachability of quicksilver. One might also say that her skin is as white as cocaine, for Dix underscores this second strand of Anita Berber's career and tragic fate. She is just 26 years old in her portrait. She will never be as old as Dix makes her look in his merciless gaze at human frailty. Three years after sitting for her portrait, she is dead, having succumbed to tuberculosis, weakened by drugs. Dance and death are joined – just as the poster had predicted – in one person.

As many who study 1920s Berlin have always known, for all the bright lights and bustling streets, decadence lurked everywhere. Morals had declined and decayed and perversions defied description. Count Kessler tells the following oft-quoted story in his diary: one evening in February 1926 he was invited to the Pariser Platz apartment of Karl Vollmoeller (1878–1948), the industrialist, playwright, later screenwriter for the film *The Blue Angel* directed by Josef von Sternberg (1894–1969), and above all a wealthy heir. Theatrical director Max Reinhardt (1873–1943) was also among the guests. Girls in various stages of undress were draped all over the sofas; they worked for little pay at the nearby Grosser Schauspielhaus and were game for anything. The attraction of the evening was Josephine Baker (1906–1975), who was causing a stir in Berlin with her Revue Nègre; she,

Stage design with Josephine Baker, *c.* 1929

Otto Dix
***Portrait of the Dancer
Anita Berber***, 1925
Tempera on plywood, 120 x 65 cm
(47¼ x 25½ in.)
Sammlung Landesbank
Baden-Württemberg
im Kunstmuseum Stuttgart

too, had nothing against nudity and proceeded to dance before the gentlemen wearing only a "pink muslin apron" (ill. p. 26). She was assisted by a fully clothed Ruth Landshoff (1904–1966), niece of the publisher Samuel Fischer (1859–1934), who was dressed in a dinner jacket. Kessler, the homosexual connoisseur, immediately began composing a ballet for them in his head, in which he imagined Miss Baker as the biblical Shulamite and "the Landshoff girl" as King Solomon. The ballet remained a project, a sweaty fantasy. In all too long-established fashion, it would have transported the scene back to the turn of the century, when Decadent was still the name of a movement in art.

This was of course a private soirée and without Kessler's eloquent diary entry, it would have remained so. Above all, it was far from a furtive encounter in a back room. Ruth Landshoff's sizzling sexuality is another of the elderly Kessler's obsessions. New, too, is the enthusiasm for the sort of foreignness that Josephine Baker embodies and which, in its exoticism, cannot be reduced to racism alone, even if it also serves it. On the contrary, Berlin's cosmopolitan culture is open to an unprecedented degree to the exquisite moment, to the fascination of the world and to diversity and mixing. The mixing of the sexes, of sexual preferences, of races and classes. The Roaring Twenties were above all things tolerant, and in this Berlin was their capital.

The custom of mixing can be seen in the appearance of author Heinrich Mann (1871–1950), who in 1930 gave a reading at Karstadt, the sensational department store on Hermannplatz in Berlin's Neukölln district that had been opened with an act of high and at the same time popular culture. Mann's pre-war novel *Professor Unrat* had just provided the inspiration for *The Blue Angel*: the film (ill. pp. 90, 91) expatiates with relish on the downfall of a humanist-minded senior school teacher who unexpectedly encounters the "naughty Lola." Such scandalous themes were now being aired in public. Another custom of mixing: in 1928, at the Sportpalast on Potsdamer Strasse, Max Schmeling (1905–2005) boxed against Franz Diener (1901–1969) for the German heavyweight title. More remarkable than the result, perhaps, is the expenditure on the programme, which features contributions from the following representatives of Berlin high culture: Leopold Jessner (1878–1945), director of the Schauspielhaus on Gendarmenmarkt; Friedrich Hollaender, the composer; Kurt Pinthus (1886–1975), the literary figure who, in the ferment of Expressionism, edited *Menschheitsdämmerung*, an anthology of poetry whose ambiguous title can mean both "The End of Civilization" and "The Dawn of Humanity" and thus succinctly summed up the contemporary mood; Herbert Ihering (1888–1977), the influential theatre critic for the *Börsen-Courier*; Carl Zuckmayer (1896–1977), the playwright, who made his name with *Der fröhliche Weinberg* ("The Merry Vineyard") and most notably *Der Hauptmann von Köpenick* (translated into English as *The Captain of Köpenick*), a smug satire on German militarism; and lastly the journalist Egon Erwin Kisch (1885–1948; ill. p. 79), whose 1924 anthology *Der rasende Reporter* ("The Roving Reporter") had spawned a job title. All these influential figures on the Berlin arts scene were readily persuaded to pay tribute to a boxing match.

Berlin was *Different from the Others*, or *Anders als die Andern* – the title of the first film to treat the subject of homosexuality in a serious fashion (ill. p. 28). Released in 1919, it was directed by Richard Oswald (1880–1963) and featured Anita Berber in a prominent role. Magnus Hirschfeld (1868–1935) served as medical advisor and also played one of the characters. Hirschfeld was the founder of the Institut für Sexualwissenschaft ("Institute of Sexual Research"), which from March 1919, from its premises in a villa in the Tiergarten park, offered advice on all aspects of sexuality – especially when this sexuality did not correspond to the proprieties. Male couples were already part of the Berlin mainstream even before the First World War, even if homosexuality was officially a crime. Generally acting with a thoroughly authoritarian mindset, Berlin police exhibited a certain leniency when it came to the implementation of Paragraph 175, which prohibited sexual relations between men. The control they wished to exercise, ran their entirely logical argument, would be easier to achieve if there were areas in which such offences were tolerated. In the overflowing Twenties, Berlin now became a magnet for the gay

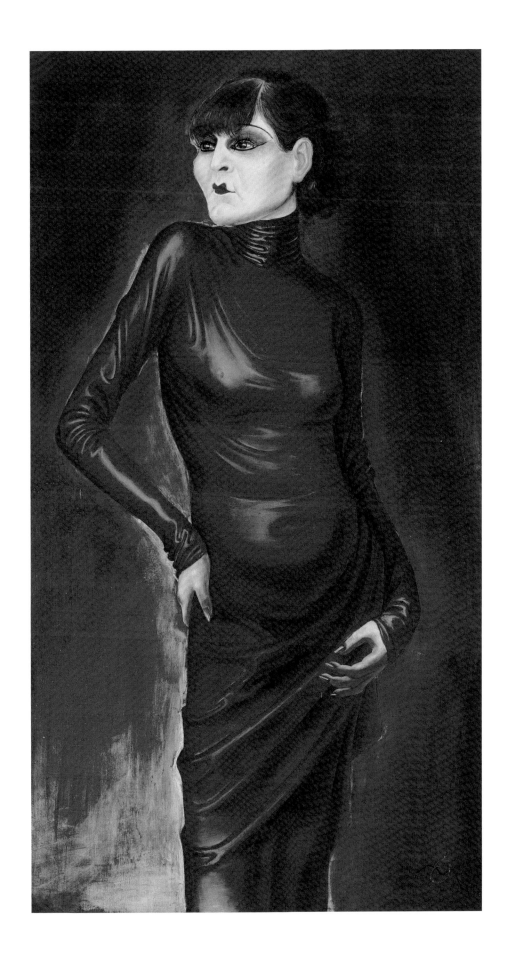

movement. Berlin was liberal, it was cheap and it was diverse. In *Goodbye to Berlin*, his farewell to freedom written at the turn of the era in 1932/33 and the basis of the musical *Cabaret*, Christopher Isherwood (1904–1986) tells of the glorious days of libertinage, when you could never be sure what sex the one-night-stand you had just picked up would be. The foil to *Different from the Others* was *Mädchen in Uniform* ("Girls in Uniform"), released in 1931. The film is the story of lesbian love in the setting of an all-girls' boarding school. Since the ominous Paragraph 175 applied only to men, the issue of lesbian love was never as problematic and was much flirted with. It was often presented as cross-dressing, so that women such as Ruth Landshoff, the sculptress Renée Sintenis (1888–1965; ill. p. 46) and indeed the Berlin icon Marlene Dietrich could remain vague about their personal proclivities. Men, on the other hand, were required to confess their allegiances more clearly.

All in all, many – whoever, whatever and however they may be – were claiming their right to personal expression and personal freedom. Other cities such as London and New York were bigger, but it was Berlin that made "mass" mean "might." In 1926 Siegfried Kracauer summed it up as follows: "Berlin's four million cannot be ignored… The more the people feel themselves to be a body, however, the more the body gains formative powers in the intellectual sphere, too."[13]

It all changes

Self-Portrait as Warner (ill. p. 6): the artist presents himself as very middle class, almost literally a white-collar worker, with his hair neatly parted, his glasses glinting energetically, his white shirt with its starched collar and a tie knotted firmly around his neck. A painter's overall shows that he doesn't want to get dirty doing the job that has now been imposed upon him. The trend towards polish and a certain classicism that emerges in post-war arts across Europe has become known in cultural history as the *rappel à l'ordre*, the "return to order." Pablo Picasso (1881–1973) painted naked boys, Igor Stravinsky (1882–1971) followed historical precedent in his compositions, and Adolf Loos (1870–1933) considered the orders of columns. George Grosz likewise shows him-

Richard Oswald
Different from the Others, 1919
Film still with Conrad Veidt in the role
of Paul Körner and Magnus Hirschfeld
as the doctor

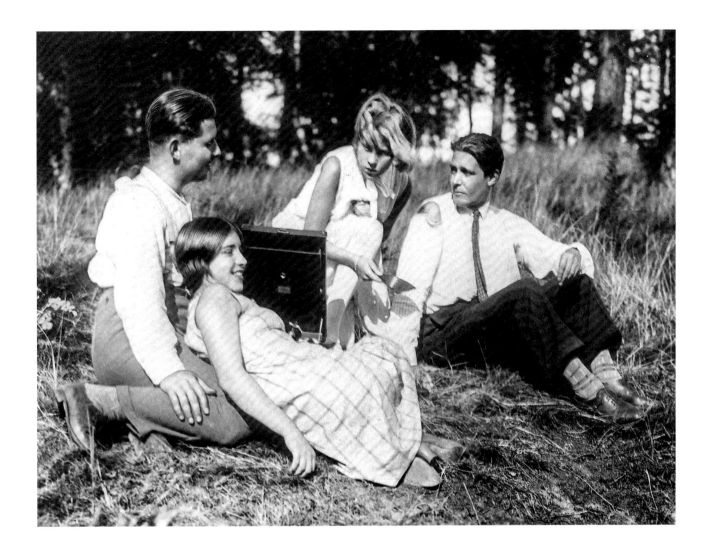

Robert Siodmak / Edgar G. Ulmer
People on Sunday, 1930
Film still of an outing scene

self a lover of order: he delivers his *rappel à l'ordre* quite literally and extends his left arm admonishingly into the warning gesture of the index finger pointing upwards. He had happily seen himself as an *enfant terrible*: in 1920, for example, he had taken part in the *First International Dada Fair*, a spectacle that would later enter the canon of great artistic provocations. All of this is in the past: now, in 1927, we are given a Grosz who is extremely reliable.

Naturally it was not yet possible to foresee how necessary a warning would be. But sensitive individuals already had a hunch. In this same year of 1927, Siegfried Kracauer writes an essay whose title will become famous: *Das Ornament der Masse* (translated into English as *The Mass Ornament*). It is meant to be a reflection, among other things, on the popular performances by female dance troupes, whose adroitly feigned goose-stepping, with its glimpses of flesh, carried military marching into the realm of eroticism and enjoyed sexually tantalizing successes on stage. But what Kracauer quite unintentionally describes is a familiar picture to anyone who knows the later Nazi marches, and in particular the Nuremberg rallies. The transposition of mass into might, on which Berlin's great culture was so keen, subsequently also wrought the transposition of aesthetics into politics. In exile in America, Kracauer would later re-examine the omens that were there – and which he somehow recognized, but nevertheless underestimated in their portentousness – in *From Caligari to Hitler*, his study of German film published in 1947. Kracauer analyzes one of the classics of Berlin cinema, *The Cabinet of Dr. Caligari*, released in 1920.

The film tells the story of a self-styled doctor who has a young man in his power, keeps him in a state of derangement and makes him commit murders. In his ability to hypnotize, his fanaticism and his cruelty, Caligari – as Kracauer is obliged to recognize – exhibits some of the very traits that will later lead an entire nation and an entire continent into the abyss.

In October 1921 Dada addressed a "Call for Elementary Art" to the Berlin art world in the form of a manifesto titled *Aufruf zur elementaren Kunst*. The central passage runs: "We deem this manifesto an action: seized by the movement of our times, we announce, with elementary art, the renewal of our vision and consciousness of the tirelessly cross-fertilizing sources of power that shape the spirit and the form of an epoch, and which allow art to arise within this latter as something pure, liberated from utility and beauty, as something elementary in the individual. We demand elementary art! Against reaction in art!"[14] A characteristic of the majority of manifestos of orthodox modernism – and this one is truly a classic example – is the fact that we are no wiser after reading them than before. This is due above all to the relentless self-referentiality of all the terms that are here so vehemently deployed. The text successively calls for "action," "movement," "renewal," "power" and its "sources," "spirit," "form," the "pure" and "liberated," and – repeatedly – the "elementary." What the action involves, where the movement is going, what the power is good for and what the elementary actually *is*, remains unsaid.

It remained unsaid until a man arrived who didn't call, but shouted. The man who, by purity, meant racism; by movement, National Socialism; by the elements, blood and soil; and by action, extermination. The man who replaced the ambiguity of concepts with the clarity of action, until the dynamism that lends the modernist manifestos their irresistibility descended into a ruthless advance, into the machinery of standardization, suppression and conquest. The post-war era in which Berlin's popular culture reached its desperate greatness had once again become a pre-war era in which it descended into folklore.

The things are connected. Suffice to look at the kitsch produced after 1933 by what called itself "German Art." Expressionism had frequently taken up simple, rustic and rural themes, but offset their conventionality with a method that invoked garish colours, crude forms and agitated brushwork (ill. p. 23). New Objectivity, by contrast, cultivated a smooth, clear and descriptive style, while focusing on the aloofness, melancholy or even violence of primarily urban settings (ill. p. 31). "German Art" took from both movements what was bad: the conventionality of the motifs of the first and the accessibility of the painterly means of the second (ill. p. 30). What came out was philistinism. As we know, art didn't stay that way.

Adolf Ziegler
The Four Elements: Earth and Water,
before 1937
Middle panel of the triptych
Oil on canvas, 171 x 109.8 cm
(67¼ x 43¼ in.)
Munich, Bayerische Staatsgemälde-
sammlungen – Sammlung Moderne
Kunst in der Pinakothek der Moderne

Christian Schad
Two Girls, 1928
Oil on canvas, 109.5 x 80 cm (43 x 31½ in.)
Christian Schad-Stiftung Aschaffenburg

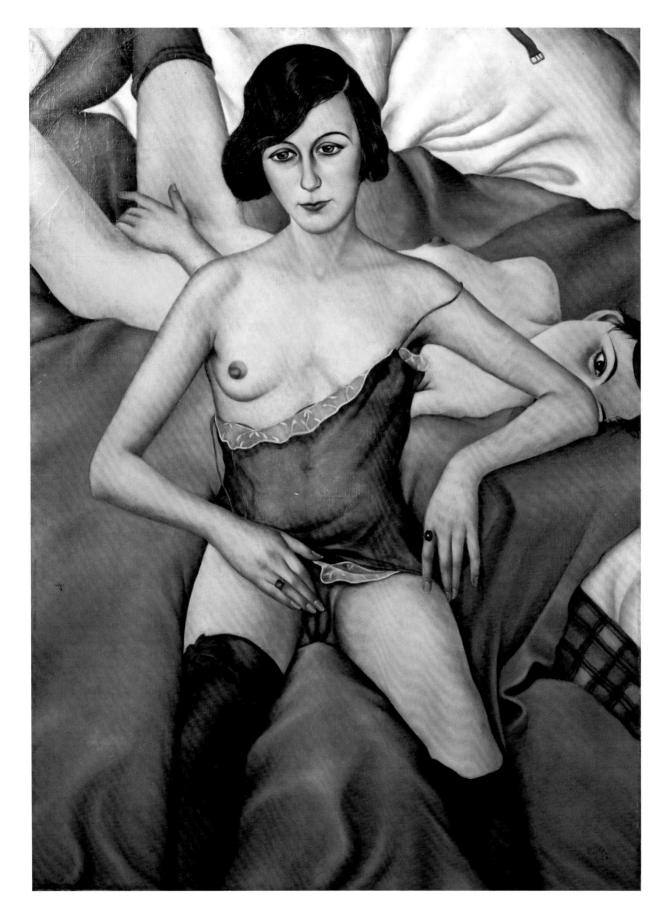

Max Pechstein
To all Artists!, 1919

b. 1881 in Zwickau
d. 1955 in Berlin

Modernism thrives on the opposition of motif and method. Its repertoire of subjects may seem familiar and include landscapes, still lifes and portraiture, yet the artistic means by which these are visualized are charged with violent intensity. Deformation is the method of choice: reality finds itself dissected, dismembered and destroyed when it comes under the artistic spotlight.

This becomes problematic when deformation as method meets deformation as motif. What to do with the violence of colour, brushstroke and expression when it comes to portraying something that already lies in ruins? When war, uprising or revolution are the subjects to be represented? Then it all seems too much at once. Then it becomes too much of a good (or bad) thing. Then, to use a rhetorical term, it becomes tautological. Or, to put it simply: then it becomes kitsch. Not sweet kitsch, perhaps, but sour.

Expressionism, as it developed around 1910, was a language of violence and pathos right from the start. After the world war, whose repercussions were felt at political and psychological levels alike, its vocabulary grew even more heated. What up till then had remained an aesthetic programme now became physically palpable. When Max Pechstein addresses his appeal *An alle Künstler!* (*To all Artists!*), he leaves us deliberately uncertain as to who or what the desperate figure swaying rather than standing in the centre is meant to be: artist, victim, addressee, his right arm raised between a call for aid and an oath, his left hand clasped to a burning heart. The whole in a garish contrast of black and red: the jargon of authenticity is striking.

Pechstein, a veteran of the Dresden artists' group Die Brücke, lived from 1908 chiefly in Berlin, where he naturally attached himself to one of the Secessions. Like almost every representative of emphatic modernism, Pechstein was a member of the Novembergruppe. Founded in the climate of widespread political unrest following 9 November 1918, the abolition of the monarchy and the proclamation of the Republic, the group's mission was broadcast in its very name: it was about carrying the achievements of the November Revolution forward into the future.

The woodcut *To all Artists!* forms the title page of a pamphlet addressed to Novembergruppe participants and to all those whom they hoped would join. It is a manifesto of the kind so loved by the avant-garde: a collection of passionate appeals, overflowing with emotive terms such as "socialism," "justice" and "freedom." As well as providing the vehement image for the front cover, Pechstein also contributed a text. He sums up his point of view in the following sentence: "Get art to the common people and the common people, through crafts, to art."

In those agitated times, the Novembergruppe formed a sort of super-Secession that brought together all that was experimental and cutting edge. It would remain in existence until 1932 and would mount various group exhibitions. Pechstein himself was only involved in the first, held in November 1919. Disillusionment had rapidly set in. He returned to the solitary path to which the artistic mentality has always been drawn. Intoxicating collectivism was a short-lived sensation, both aesthetically and politically. Pechstein lent it a powerful image. RM

An alle Künstler!
(*To all Artists!*), 1919
Title page of the pamphlet
Cardboard with woodcut
in red and black, 19.7 x 13.8 cm
(7¾ x 5½ in.)

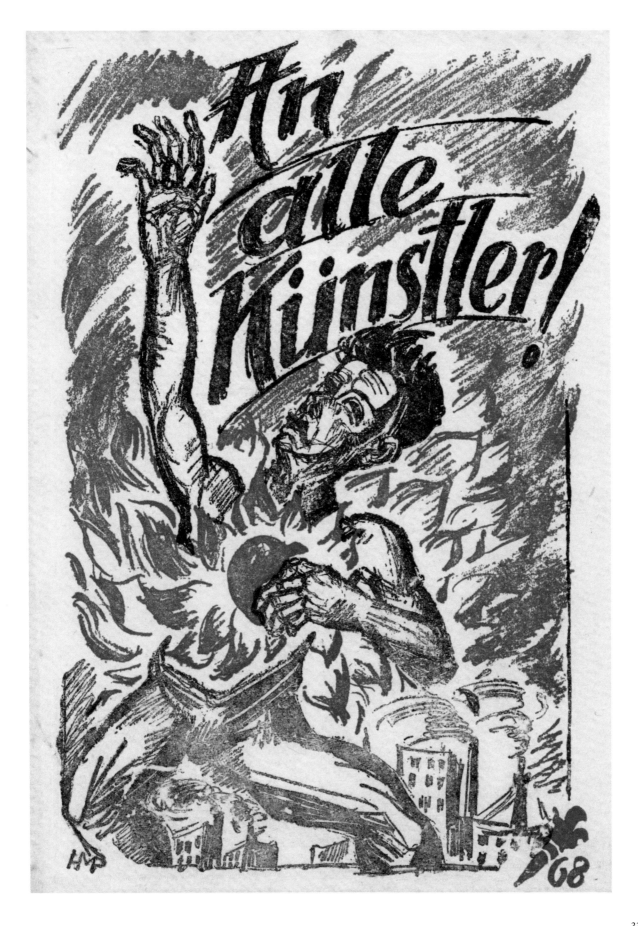

Hannah Höch

Incision with the Dada Kitchen Knife through Germany's Last Weimar Beer-Belly Cultural Epoch, 1919

b. 1889 in Gotha
d. 1978 in Berlin

Schnitt mit dem Küchenmesser Dada durch die letzte Weimarer Bierbauchkulturepoche Deutschlands (*Incision with the Dada Kitchen Knife through Germany's Last Weimar Beer-Belly Cultural Epoch*) by Hannah Höch is one of the artist's most important works. In 1920 the montage was on prominent display – as documented by contemporary photographs – at the *First International Dada Fair* staged in Otto Burchard's art bookshop on Lützowufer in Berlin. The 27 artists represented at the show also included Raoul Hausmann, Otto Dix, George Grosz and John Heartfield. In comparison to the group formed in 1916 in Zurich, Dada Berlin was markedly more provocative and political. Although Höch's montage numbered among the show's key exhibits, she was largely ignored by other Dadaists: the "New Woman" – and hence also the woman active as an artist – who belonged, at least in the press, to the achievements of the Weimar Republic and its socio-political new beginning, typically played almost no role here.

Höch's montage arranges pictures and words cut out of newspapers and magazines – sources which were readily available to her in her job as a graphic designer and author for Ullstein Verlag publishers. The result is a miniature cross-section through contemporary society. The "Dada kitchen knife" of the title can be associated with the role of the housewife, but it also refers to the radical cutting-out and re-arranging to which Höch subjects her material. "Disproportions between huge heads and small bodies, between outsize letters, machine parts and tiny figures," writes Silke Wagener, "are not toned down by the artist but are emphasized, and make clear both her ironic handling of the material and new contexts of meaning within the montage."

Prominent within the composition are the wheels and ball-bearing tracks around which the arrangement revolves. For the avant-gardists, the 20th century stands for the driving force of machines, which are progressive and destructive in equal measure. Höch's integration of text fragments is typical of the Dadaists. Most interesting of all, however, is her incorporation of well-known figures of the day – representatives of politics, science and industry. Höch portrays a society in transition, a "male cosmos," as Jula Dech observes. If Dadaist thinking is the instrument with which the cut through society is made, the "beer-belly cultural epoch" refers to the reactionary forces. Grouped under the heading of "anti-Dada" are consequently those who stand for reaction – first and foremost Kaiser Wilhelm II, who had been forced to abdicate in November 1918 in the course of the Revolution. With regard to the political chain of events, his appearance in the montage close to Bismarck is significant. In contrast to these sinister, static emblems of militaristic policy, Höch groups artists and radicals under the forces of reaction. Noteworthy, too, is a map of Europe lower right, highlighting those countries in which women have already been given the right to vote. Höch has integrated a jerboa (a hopping desert rodent) into the Soviet Union, at that time a land of hope for many of those leaning towards the political left. The references to the artist Käthe Kollwitz (1867–1945), the writer Else Lasker-Schüler (1869–1945) and the actress Asta Nielsen (1881–1972) may be understood in a similarly positive sense: in this panorama they represent productive female creativity. UZ

Incision with the Dada Kitchen Knife through Germany's Last Weimar Beer-Belly Cultural Epoch, 1919
Collage, 114 x 90 cm (45 x 35½ in.)
Staatliche Museen zu Berlin –
Preussischer Kulturbesitz, Nationalgalerie

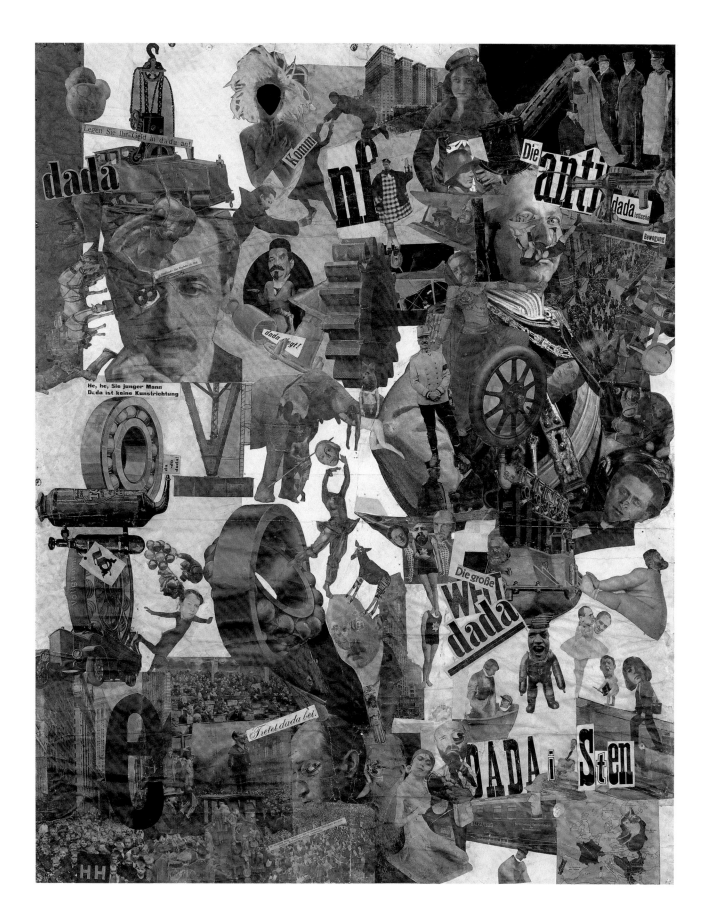

Hans Poelzig
Grand Theatre, 1919

b. 1869 in Berlin
d. 1936 in Berlin

"A menacing, revolutionary structure" was how the critic Karl Scheffler described the building after its inauguration in 1919, a year after the November Revolution. The Grosses Schauspielhaus (Grand Theatre) on the embankment of the River Spree was indeed massive, but its history went back to imperial times. Originally built in 1866 as a covered market, in 1879 it was bought by circus director Ernst Jakob Renz (1815–1892) and later became famous as the Zirkus Schumann. In 1918 theatre director Max Reinhardt took over the building. Reinhardt had already conceived his plans for a grand-scale "Theatre of the 5,000" in spring 1914. As a theatre movement by and for the masses, it aimed to effect a change in society using means that were educational as well as entertaining.

After several false starts, Reinhardt finally found in Hans Poelzig an ideal partner with whom to build his theatre. In addition to his successful career as an architect practising and teaching in Breslau, Dresden and Berlin, Poelzig also had experience in designing stage sets. In 1919 he was appointed chairman of the influential and progressive German Werkbund. At his very first meeting with Reinhardt, Poelzig sketched the idea for the Grosses Schauspielhaus on a serviette: a circular building beneath a domed roof and with the stage at its centre, like a circus ring. It symbolized Reinhardt's non-hierarchical concept of theatre.

Within an astonishingly short period, given the turbulent times, Reinhardt and Poelzig turned their plans into reality. Poelzig achieved the difficult task of adapting much of the building as it already stood in order to suit his new purposes. He integrated the existing cast-iron pillars, which for reasons of stability could not be removed, and sheathed them in wire netting and plaster. This makeshift solution became an expressive statement, particularly as Reinhardt clad the entire dome with concentric rings of cones hanging downwards. The interior adopted design principles of Islamic domes and resembled a vast cavern – a spatial association that Poelzig pursued in several of his buildings. The pillars in the foyer recalled Minoan temples and the gabled front facing the River Spree a Babylonian stepped pyramid. The theatre soon became known among Berliners as the "limestone cave" and the "art ziggurat."

Other contemporaries were far less merciful: the plaster cladding was perceived as window-dressing and earned Poelzig accusations of cheap pathos. Critics failed to see that this stage-set theatricality was the actual aim of the interior design. The hanging dome offered a way to install highly effective indirect lighting, moreover, and in technical terms the building as a whole was one of the most modern of its day. It seated an audience of 3,500. The hardest challenge for Poelzig proved to be Reinhardt's insistence that the theatre should incorporate a frontal stage, which was detrimental to the centrality of the circular building.

During the Weimar Republic the house was the setting for mass theatre and mass entertainment. In 1943 it was badly damaged and Poelzig's hanging dome was never rebuilt. As part of the GDR, the Grand Theatre – now renamed the Friedrichstadtpalast – became a firm feature of cultural life in East Berlin. Structural problems – the building rested on pile foundations in marshy ground – ultimately led to the demolition of the building, despite protests, in 1988. MN

Grand Theatre, 1919
Berlin, Am Zirkus 1
Auditorium with stalactite-like cones
("limestone cave")
Photo of 1920

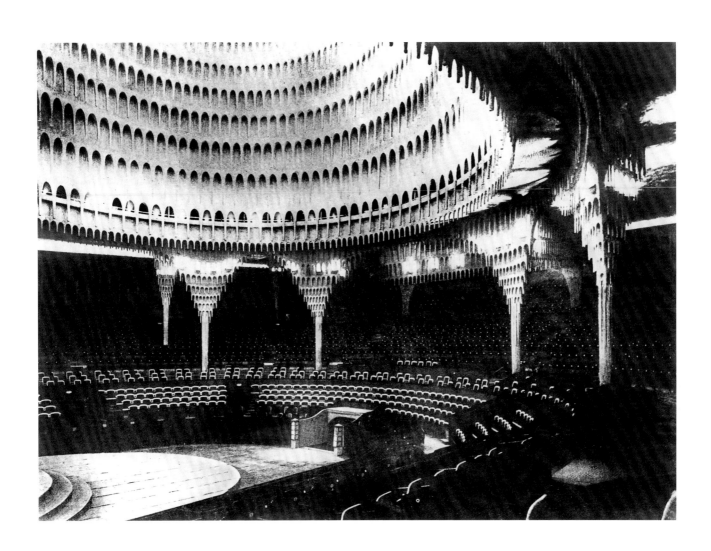

Raoul Hausmann
Mechanical Head (The Spirit of Our Age), 1919

b. 1886 in Vienna
d. 1971 in Limoges

The Dada movement (between 1916 and 1922) may have been short-lived, but Dadaist forms of expression and aesthetic strategies nevertheless had an enduring impact on the development of 20th-century art.

Dada understood itself as an artistic reaction to the First World War, which represented the collapse of civilization on an incomprehensible scale. In view of this catastrophe, art – thus Dada – had to be radically different. The goal was to lend reality in all its contradictions an appropriate, contemporary form of expression, since the bourgeois artistic and cultural creed of Truth, Beauty and Good had now been exposed as a preposterous absurdity. For the Dadaists, the paintbrush and palette had now had their day, as had the notion of the creative artist genius. They emphatically rejected art for art's sake. As "creatures of their epoch," as they proclaimed in their *Dada Manifesto* of 1918, it was their goal to find entirely new forms of articulation for their time.

The Berlin Dadaists, who voiced their social criticism more sharply and more directly than their international colleagues, made the media of collage and assemblage their very own. In his 1918 manifesto *Synthetisches Cino der Malerei* ("Synthetic Cinema of Painting"), Raoul Hausmann, one of the protagonists of "Club Dada," identified what was to be created, namely "miraculous constellations in real material." According to Hausmann, "The doll a child throws away, or a brightly coloured scrap of cloth, are more essential expressions than those of some jackass who wants to [immortalize] himself in oil paint."

An icon of Dadaism, the assemblage *Mechanical Head* is the symbol of an epoch, as implied by its subtitle *The Spirit of Our Age* (a later addition). The sculpture is constructed from a hairdresser's wig-making dummy, furnished with a section of measuring tape in centimetres, onto which have been mounted a ruler, a typewriter cylinder, a pocket watch mechanism, the number "22," a bronze segment of a camera, brass screws at the temple and, towards the rear, a used crocodile wallet. Crowning the head is a collapsible cup. All of these items are concerned with measurement, organization and calculation.

Frequently understood as Dadaist mockery of an ordinary person from the land of poets and thinkers, here in the shape of a small-minded and empty-headed German who is subject to external constraints, the *Mechanical Head* is at the same time a demonstration of the new direction in art. The work stands for the process of the revaluation of art: individual expression and a subjective expressivity are here replaced by the factual character of machine-made, everyday things.

The Dadaists built, assembled, nailed and glued their art like engineers. In this respect the *Mechanical Head* stands for the loss of personality suffered by the alienated modern individual. What also reveals itself in this work, however, is the belief in a creative association of art and science and the positive notion of a synthesis of mind and machine. For Hausmann this was the deeper significance of the new vocabulary of form: "through the demonstration of the puppet-like quality and the mechanization of life, through apparent and real rigidity, to enable ourselves to divine and feel another life." RB

Mechanical Head
(The Spirit of Our Age), 1919
Assemblage, 32.5 x 21 x 20 cm
(12¾ x 8¼ x 8 in.)
Paris, Musée national d'art moderne,
Centre Georges Pompidou

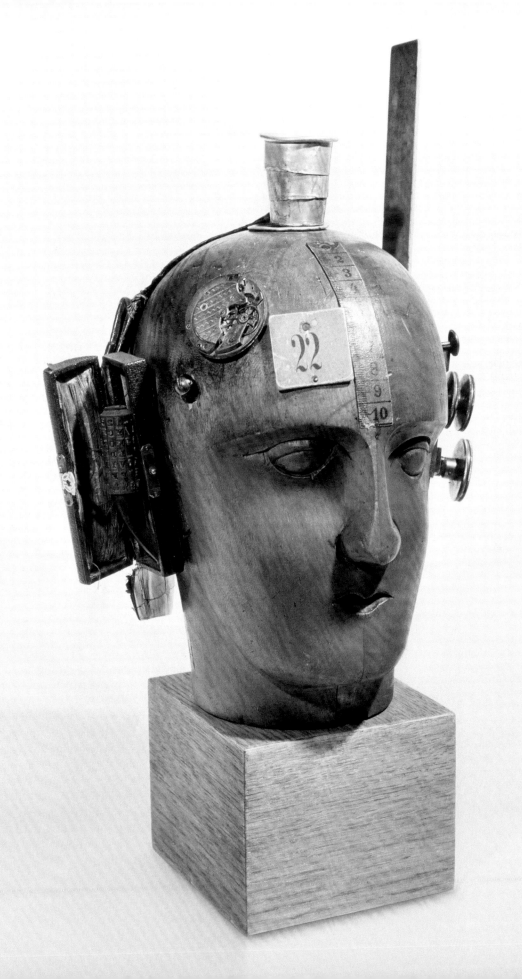

George Grosz
Untitled, 1920

b. 1893 in Berlin
d. 1959 in Berlin

In this period, with the revolution losing steam and guns quite literally at the ready to crush it, the artist strictly speaking had better things to do. He needed to rouse the people and for that, paintings were a little too self-referential and restrained. George Grosz therefore concentrated around 1920 on graphic works, which he assembled into caustically titled portfolios such as *God with Us*. In drastic images accompanied by captions in French, German and English, he showed how militarism continued to flourish uninterrupted in the new Republic and how the old hierarchies remained unchallenged and their representatives as brazen-faced as ever. Grosz concluded *God with Us* with a portrait of a Prussian officer, his cretinous profile sarcastically captioned "Made in Germany" in English and *"Den macht uns keiner nach"* ("None can imitate us") in German, the latter a line taken from Heinrich Mann's novel *Der Untertan (The Loyal Subject)*. Hot on the heels of the portfolio's publication came the charge of "defamation of the military" and a court case.

We see a very different kind of Grosz in the large painting that remains without a title. Turning away from the heatedness, gesturing and violent agitation that held sway in the years immediately after the war, the artist withdraws into anonymity. The scenery is faceless, expressionless and devoid of emotion. The walls rise silent and cold, and the figure in front of them is a tailor's dummy. The central foreground is blocked by a cube, a piece of pure geometry, assiduously draped onto the canvas in foreshortening. The buildings, too, succeed each other in perspective fashion along a vanishing point.

As if needing to reassure himself of his metier, Grosz returns to the tools of the trade employed by the Old Masters. In Italy there was a contemporary who, in similar fashion, wanted to cut through the confusion of the world with the cool rationality of centralized perspective: Giorgio de Chirico (1888–1978), the founder of a behavioural theory of coldness which he called *Pittura metafisica* (Metaphysical Painting). The two men knew of each other. But Grosz, who in 1916 had anglicized his name to George, felt more closely drawn to America.

Thus his *Untitled* painting anticipates, to a degree, the trends that emerge with the appearance of New Objectivity. In 1919 the Bauhaus had been founded in Weimar. The school of modernism would become famous for clear forms, clean objects and a pure ethos, but in 1920 its unmistakable aesthetic was as yet a long way from being established. In 1923 one of the Bauhaus teachers, Oskar Schlemmer (1888–1943), would speak of the need to build a "cathedral of Socialism." Only later would the Bauhaus incorporate working with industry as part of its programme, at which point the revolution was well and truly over.

In Grosz's painting, collaboration with industry has already been agreed. The area he has depicted looks very much like a factory complex, and the figure that inhabits it seems to correspond to an assembly-line process. That there is nothing pleasant about this future, born out of the spirit of mechanization, goes without saying. Hopes had long since given way to scepticism, and the utopias had become dystopias. The most famous literary vision of a dystopian society is portrayed by George Orwell (1903–1950) in *1984*. The earliest was written by a Russian named Yevgeny Zamyatin (1884–1937) and bears the title *We*. The book appeared in 1920. With his painting, Grosz finds himself in the best pessimistic company. RM

Untitled, 1920
Oil on canvas, 81 x 61 cm (32 x 24 in.)
Düsseldorf, Kunstsammlung
Nordrhein-Westfalen

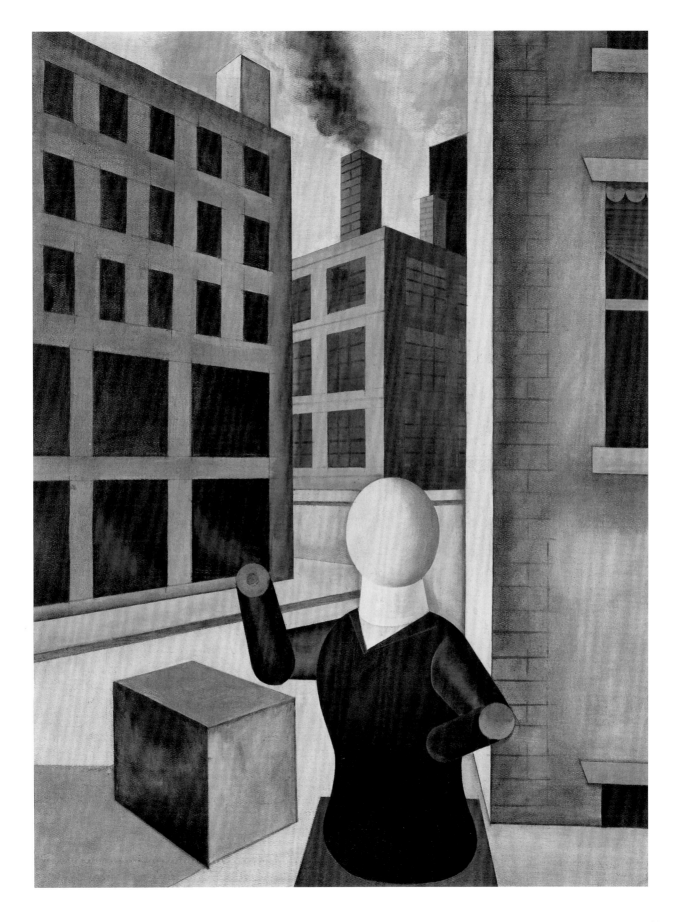

Ludwig Mies van der Rohe
Friedrichstrasse Skyscraper Project, 1921

b. 1886 in Aachen
d. 1969 in Chicago

"On the advantages of tower blocks and the conditions under which they can be built in Berlin" – thus the architect Bruno Möhring (1863–1929) titled a lecture he delivered in 1920 in Berlin. Even though, so soon after the First World War, the economy had not yet recovered sufficient strength for the construction of high-rise buildings, the company Turmhaus AG was founded for precisely this purpose. It acquired a triangular plot between Friedrichstrasse railway station and the River Spree and on 1 November 1921 launched a competition inviting ideas for a building 80 metres (262 ft) in height. The exhibition of the 144 entries, held in February 1922, prompted much public debate, but neither the winning design, submitted by the architects Baecker, Brahm and Kasteleiner, nor any of the other proposals were implemented.

From the point of view of the history of architecture, the competition became famous for a project that the jury rejected: the idea submitted by Ludwig Mies van der Rohe under the title *Wabe* ("Honeycomb"). The young architect from Aachen had previously only attracted attention with a number of finely composed villas in Berlin and the surrounding area, but there was nothing middle-class or conservative about his design for the Berlin high-rise competition. While many other entries oriented themselves towards the stylistic exercises of the 1870s, Mies envisaged a skyscraper that consisted entirely of glass – probably knowing that, from an engineering point of view, such a structure was currently still impossible to build.

His ground plan utilizes almost the entire triangular plot. Around a foyer with elevator shafts in the centre, three lateral wings – serrated, offset and tapering to a point – cluster like leaves around a stalk. Stacked upwards and clad in glass, the towering complex presents the overall picture of a nested prism, whose façade elements richly reflect each other. This crystalline image was further reinforced by Mies's famous charcoal drawing of his design, in which he blurs its sharp contours and portrays his building rising above its emphatically sombre neighbours as a tower illuminated from within.

In 1922 Mies van der Rohe published his project in the journal *Frühlicht*, together with a further proposal for a glass high-rise that offered a variant upon his "honeycomb" design for Berlin. In his accompanying text, Mies for the first time formulated his idea of reducing architecture to skin and bones. He later encapsulated this notion in the phrase "Less Is More," which would become his most famous creed. "Only skyscrapers under construction reveal their bold constructive thoughts, and then the impression made by their soaring skeletal frames is overwhelming. With the raising of the walls this impression is completely destroyed; the constructive thought, the necessary basis for artistic form-giving, is annihilated and frequently smothered by a meaningless and trivial jumble of forms."

He was only able to implement his plans for skyscrapers after his emigration to the USA. His two Lake Shore Drive apartment blocks in Chicago (1951) and his Seagram Building in Manhattan (1958) are today icons of classic modernism and the principle that "Form Follows Function." His Berlin project of 1921 thus laid the foundation stone for a key feature of 20th-century urban architecture. The plot next to Friedrichstrasse station, by contrast, remained undeveloped right up to the start of the 21st century. MN

Friedrichstrasse Skyscraper Project, 1921
Exterior perspective from north
Charcoal and graphite on paper mounted on board, 173.4 x 121.9 cm (68¼ x 48 in.)
New York, The Museum of Modern Art

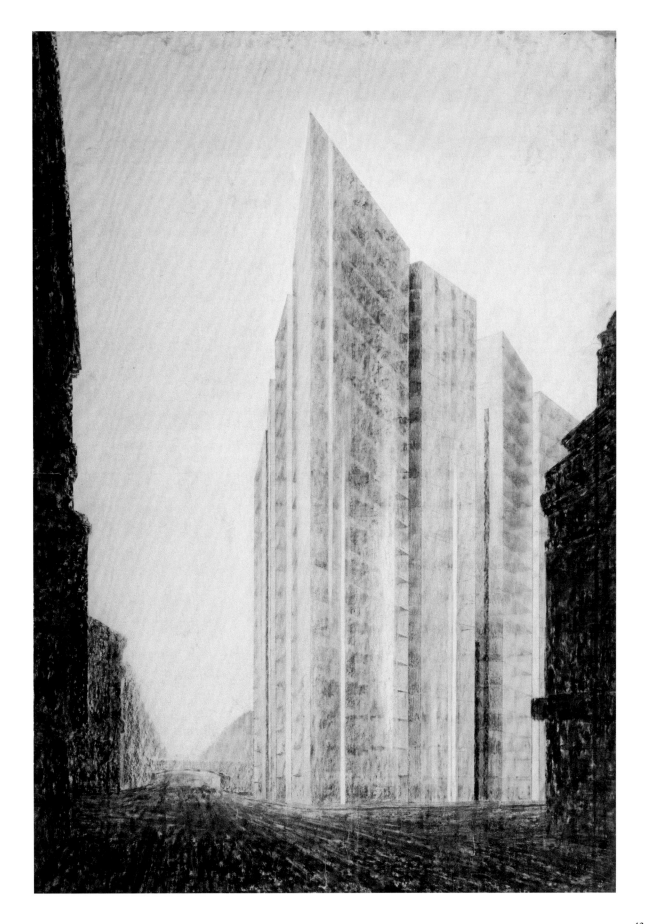

Max Beckmann
Trip to Berlin, 1922

b. 1884 in Leipzig
d. 1950 in New York

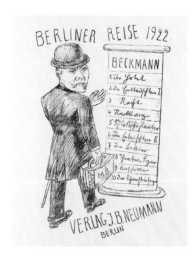

Self-Portrait with Suitcase, 1922
Cover from the portfolio *Trip to Berlin*
Lithograph on bookboard, 70 x 56.5 x 1 cm
(27½ x 22¼ x ½ in.)

Striptease, 1922
Sheet 4 from the portfolio *Trip to Berlin*
Publisher I. B. Neumann
Lithograph
Picture: 47.2 x 37 cm (18½ x 14½ in.)
Sheet: 68 x 53.5 cm (26¾ x 21 in.)
Berlin, Berlinische Galerie,
Landesmuseum für Moderne Kunst,
Fotografie und Architektur

There are some artists whose work seems quintessentially bound up with a particular city. Just as Pierre-Auguste Renoir (1841–1919) is often associated with Paris, Max Beckmann is perceived as a Berlin artist, although he was neither born there nor spent much of his life in the metropolis. And yet even the very first monograph about him, published in 1913, claimed that Beckmann would be "hard to imagine" without Berlin, and that "battle, tragedy, nudity, will, energy, brutality, force, nerves and spirit" found their counterparts in his artistic œuvre and the city on the River Spree.

Beckmann was interested above all in the "human orchestra," as he called it, i.e. the interplay of individuals in the hustle and bustle of city life. After relocating permanently from Berlin to Frankfurt am Main in 1915, he regularly returned to the capital in order to take visual readings of its pulse during these times of historic change. In his graphic œuvre, too, he showed himself an independent observer of the social and political situation between the collapse of the German Empire and the first faltering steps of the young Weimar Republic. In spring 1922 the nationwide art dealer Israel Ber Neumann (1887–1961) published Beckmann's fourth major – and at the same time last – portfolio: the ten-part lithograph series *Berliner Reise* (*Trip to Berlin*).

Having taken the consequences of the First World War and the revolutionary upheavals in Germany as the theme of a previous portfolio, which he titled *Die Hölle* (*Hell*; 1919), Beckmann saw, in his artistic documentation of the circumstances in 1922 Berlin, a sequel and a moral complement to this earlier work. The distance from which he now observed his subjects precipitated into a change of style, which seems calmer and more objective. This sober manner of representation reflects the atmosphere of these years, in which people's hopes for better times after the revolution had long since given way to anxiety over meeting their daily needs.

The Disillusioned (after whom Sheet 2 is titled) were to be found both among the former Prussian elite, subscribers to the anti-democratic *Kreuzzeitung* newspaper, and among left-wing intellectuals. In Sheet 6 Beckmann portrays the publisher and art dealer Paul Cassirer (1871–1926) standing on the right; his wife, the actress Tilla Durieux (1880–1971); on the left the musician and cultural politician Leo Kestenberg (1882–1962); and in the middle the painter Max Slevogt (1868–1932) – all of them likewise disillusioned, although in their case by the Socialists, with whom their allegiance lay, and by the way in which they were weakening themselves politically with internal disputes.

Beckmann focuses on the cramped living conditions enduring by the working classes (Sheet 3, *Night*) and the struggle for survival of the omnipresent men disabled by war injuries (Sheet 7, *The Beggars*), as well as on the public at large. Faces are rendered with caricature-like exaggeration as they pursue entertainments of all kinds (Sheet 4, *Striptease*, ill. p. 45; Sheet 5, *The Iceskater*; Sheet 8, *The Theatre Lobby*; Sheet 9, *Tavern*). In *Self-Portrait in the Hotel* (Sheet 1), Beckmann presents himself as the chronicler of this global theatre. In the final print, *The Chimneysweep* stands symbolically above the chaotic activity below: he alone can see the sun. RB

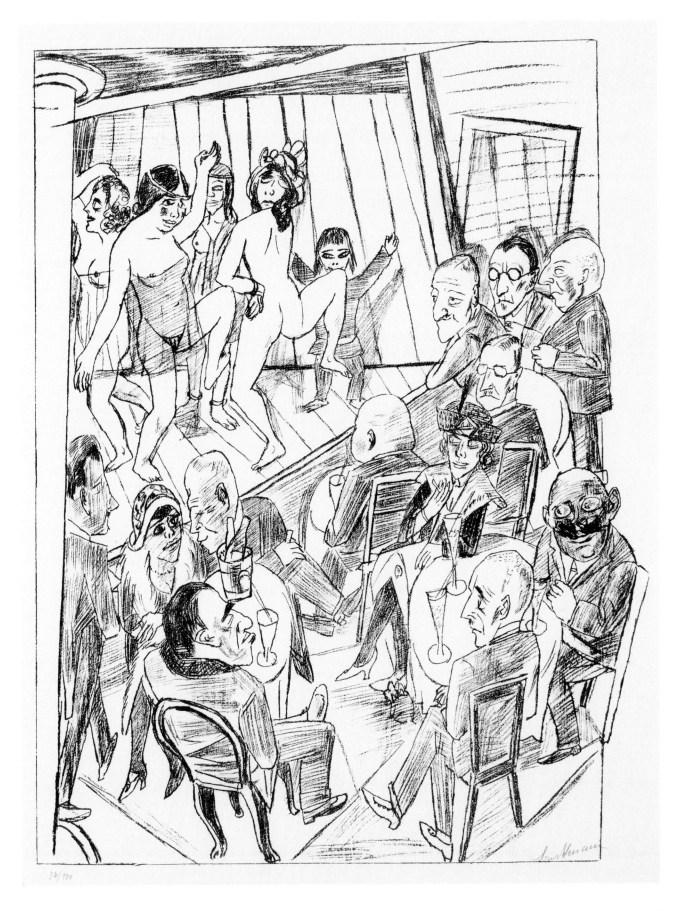

34/100

Renée Sintenis
Self-Portrait, 1923

b. 1888 in Glatz (Kłodzko)
d. 1965 in Berlin

One of the many photographs of Renée Sintenis, born as Renate Alice Sintenis, shows her in her car in the 1920s looking supremely self-confident. With her tall, slim frame and short hairstyle, her financial independence at this point in time and her wide circle of friends – among them Rainer Maria Rilke (1875–1926) and Joachim Ringelnatz (1883–1934) – she qualified in the eyes of the contemporary media as the "New Woman" of the era. Emancipated and athletic, she embodied the female ideal. Together with actress Tilla Durieux she is considered the "hub of ultramodern artist life."

A sculptress and graphic designer, in 1931 Renée Sintenis became only the second woman after Käthe Kollwitz to be accepted into the Fine Arts department of Berlin's Academy of Arts. In his introduction to an exhibition catalogue of 1929, the Surrealist writer René Crevel (1900–1935) said of her and her work: "The enchanting medley of animals and young men will long continue to bear witness to the Berlin youth of today, to a great woman who is carrying Germany's fame around the world. At last a German artist who is worth as much on the Seine and the Hudson as on the Spree and the Rhine." In 1929 *Vanity Fair* presented her as "the most interesting of women sculptors."

Although – in contrast to many successful artists of the 1920s – Sintenis was not banned from exhibiting under the Third Reich, she was expelled from the Academy and in 1934 one of her self-portraits was held up as an example of Degenerate Art. Her teacher and husband Rudolf Weiss (1875–1942) was dismissed from his post after criticizing the regime. Between 1933 and 1945 she also lost many of her friends as a consequence of persecution and emigration – first and foremost her influential patron and gallerist Alfred Flechtheim (1878–1937), who from 1920 onwards was instrumental in promoting her work at home and abroad.

Sintenis enjoyed renewed success after the Second World War. The Silver and Golden Bear statuettes awarded annually at the Berlin International Film Festival, for example, are her designs. Animals, female nudes, athletes and portraits were among her favourite subjects: "Sintenis decided at the outset upon the small form, as if she wanted to counter with scorn the excessively fleshy, exaggeratedly proportioned figures of her teacher." (Silke Kettelhake)

Alongside heads of André Gide (1869–1951) and Ringelnatz, Sintenis also regularly created portraits of herself. The sculpture of 1923 is the third of seven such self-portraits. While those after the Second World War document the years of loneliness and ageing, the present sculpture shows the artist at the beginning of her career. It conveys the features that were regularly stressed by her contemporaries: the high cheekbones, the strikingly classical, almost idealized profile and the androgynous nature of her appearance. At the same time, the expression remains unapproachable and introspective.

Her sculptures were on show at Flechtheim's gallery alongside those by Georg Kolbe (1877–1947) and Ernst Barlach (1870–1938) and in the 1920s they sold to major collectors around the world, including the Rockefellers (New York), the Courtaulds (London) and the Templeton Crockers (San Francisco). UZ

Self-Portrait, 1923
Plaster, 30 x 15 x 20 cm (11¾ x 6 x 8 in.)
Kunsthalle zu Kiel

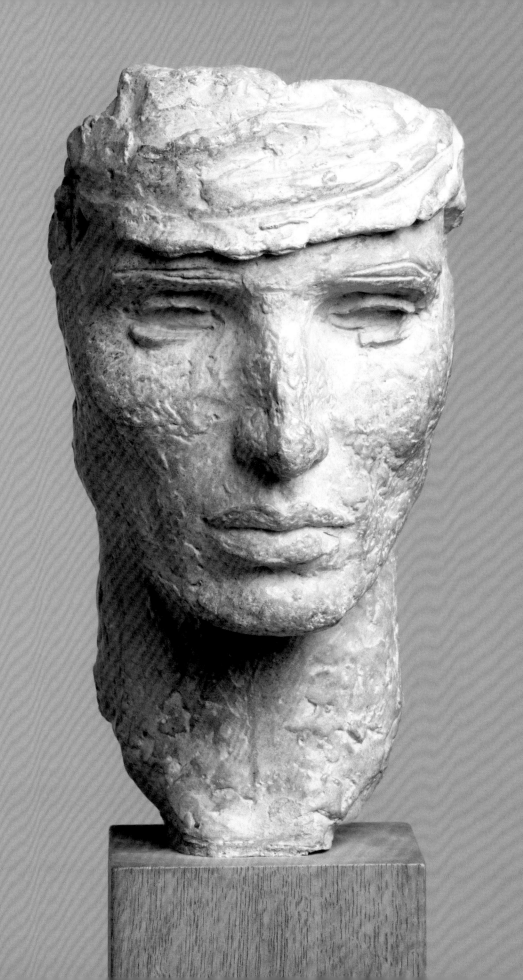

Heinrich Straumer
Funkturm Radio Tower, 1924–1926

b. 1876 in Chemnitz
d. 1937 in Berlin

"Just as the image of uniformed statesmen, of philosophers and artists belongs to the sweeping curves of the terraces at Sanssouci, so the image of men of industry, organizers, of the tirelessly busy men of the civic administration, of merchants and engineers, and of the vast army of workers belongs to the slender iron frame of the tower in Witzleben, fitted with the latest technical equipment." An edifice for a new age, a symbol of the urban society of the 20th century and its achievements: thus architect Heinrich Straumer proudly lauded his own work, the Berlin Funkturm radio tower, built between 1924 and 1926.

Only a few years earlier the fringes of Grunewald forest had still reached as far as the west of Berlin, where the slender steel structure rises 146.7 metres (481 ft) high with antenna. At the beginning of the 1920s, the Deutsche Reichspost postal service earmarked the area as the site for its Witzleben transmitter. Berlin's association of radio industries also drew up plans to construct a new exhibition centre at the same location, in order to present its latest products and developments at the *Funkausstellung* trade show, which is still held today. The Funkturm thereby took on the role of demonstrating the state of the art of broadcasting – in the Twenties, an innovative and rapidly developing technology. Radio tower and exhibition centre entered into a symbolic and functional symbiosis and jointly became part of the Berlin cityscape.

What began in 1924 with the first *Grosse Deutsche Funkausstellung* ("Great German Radio Exhibition"), housed in the "Haus der Funkindustrie" exhibition hall (also designed by Heinrich Straumer), would evolve in the years up to the Second World War into a success story on a massive scale: the site was expanded and new buildings added almost non-stop up to 1937. In 1929/30 an overall master plan was drawn up by chief city planner Martin Wagner and architect Hans Poelzig.

The Funkturm, however, remains the undisputed focal point of the arena and a landmark of Berlin right up to this day. In comparison to its model, the Eiffel Tower erected in 1889 in Paris, it is considerably more slender, delicate and simple, not least due to the necessity of keeping costs down, which allowed for no elaborate details. The elevator is situated in the central axis, rather than travelling at an angle as in the frame of the Eiffel Tower. The silhouette of the Funkturm does not curve inwards from broadly spaced feet, but rises straight and almost vertical. These characteristics made it the model for many subsequent 20th-century masts hallmarked by pure technological efficiency.

Architect Heinrich Straumer was responsible above all for the design of the panoramic restaurant at a height of 48 to 57 metres (157 to 187 ft), with its two pagoda-like levels one above the other, and for the observation platform at 121 metres (396 ft). He had previously made his name less with engineering designs than as the builder of dignified modern villas in the country-house style. The opulently furnished restaurant with its stucco ceiling, wood panelling and intarsia is in marked contrast to the industrial character of the tower itself.

On 22 March 1935 the Funkturm's antenna broadcast the world's first regular television programme. The tower – also known colloquially as the "Langer Lulatsch" ("lanky lad") – was damaged in the Second World War but was afterwards rebuilt true to its original design. Since 1961 it has been a protected monument. MN

Funkturm Radio Tower, 1924–1926
Exhibition centre with Funkturm
and Deutschlandhalle
Photo by Hermann Reinshagen, 1939

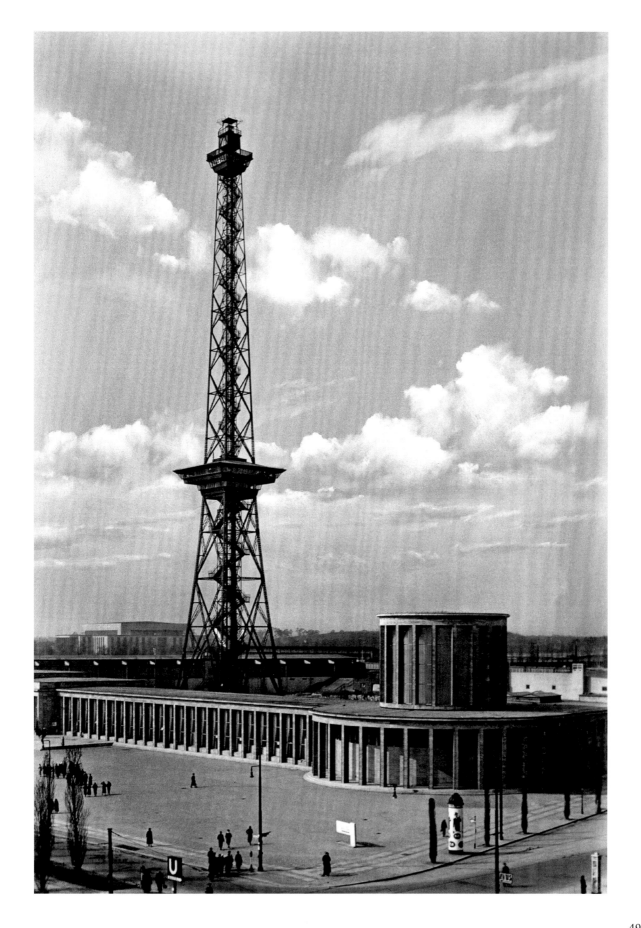

Edwin Scharff
Standing Female, 1925

b. 1887 in Neu-Ulm
d. 1955 in Hamburg

On the evening of 30 August 1929 the sculptor Edwin Scharff is one of the guests at the home of the banker and politician Hugo Simon (1880–1950) and his wife. Simon was formerly Prussian Finance Minister in the revolutionary days after the end of the war, but first and foremost he is a member of high society. He is part of the Establishment – with friends in particular on the cultural scene. Anyone who dines with Simon has made it to the top. Edwin Scharff, who was born in Neu-Ulm and who trained in Munich before arriving in Berlin in 1923 to take up a professorship at the Hochschule für Bildende Künste, has done just that. Scharff can count himself among the successful. And among those who have adapted to their environment.

We owe the report of that dinner at the Simons', like so many other accounts of Berlin society, to Count Harry Kessler. He tirelessly confides the events of these years to his diary, which is chronicle and tabloid in one. Above all, Kessler stands for a particular taste. He embodies an aesthetic attitude that is representative of the upper class and is correspondingly a little conservative. It may follow trends, but is not really progressive and certainly does not extend to the latest achievements of the avant-garde. Its ideal is the image of man and the human body as portrayed by classicism, whose careful attention to figure, shape and proportion has endured over the centuries.

Edwin Scharff's sculpture corresponds to precisely this attitude. In the case of a bronze such as *Standing Female* of 1925, he creates a sculpture whose height of 64 cm (25¼ in.), statuette character and feminine form perfectly match the tastes of bourgeois collectors. The zeitgeist is thereby firmly on the artist's side: for all their ardour and turbulence, the Twenties were also years of the so-called *rappel à l'ordre*, the "return to order" that brought even grand masters such as Pablo Picasso and Henri Matisse (1869–1954) back to the canon of antiquity. In certain departures, art shows that it has passed through phases of deformation and rebellion. From this perspective, Scharff's modello-like *Standing Female* has internalized the achievements of modernism. In some ways it has left them behind, for in contrast to modernism it emphasizes the timelessness of human anatomy. The technique does the rest: bronze stands for solidity, high-quality workmanship and survival through all eventual upheavals.

The year after Scharff produced his *Standing Female*, he was awarded the most prestigious commission of his career. In 1926 he created an over-lifesize bust of Paul von Hindenburg (1847–1934), the First World War general and now President of the Weimar Republic. Hindenburg the person transcended time, here embodied in its artistic manifestations by classicism. In Hindenburg, the breakneck pace of modern politics was tempered and the state promised something like continuity. Edwin Scharff did the same in his own, sculptural fashion. He conveyed to his pubic something like a calm sea that is ruffled by waves only on its surface.

In 1931 his œuvre, which trod an emphatically moderate course, secured him a place in the lofty Prussian Academy of Arts. But the Nazi regime stripped Scharff of his position and influence, at first insidiously and in 1937 definitively. RM

Standing Female, 1925
Bronze, 64 x 23 x 18 cm (25¼ x 9 in.)
Nachlassgemeinschaft Edwin Scharff,
foundry stamp H. Noack/Berlin Friedenau
Neu-Ulm, Edwin Scharff Museum

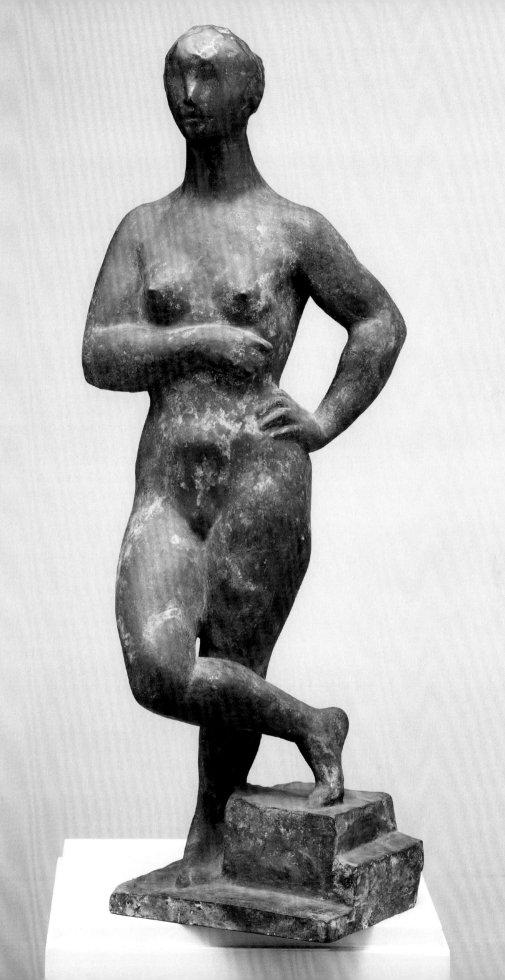

El Lissitzky / Hans Arp (eds.)
The Isms of Art, 1925

El Lissitzky
b. 1890 in Pochinok
d. 1941 in Moscow

Hans Arp
b. 1886 in Strasburg
d. 1966 in Basel

Kunstismen
(*The Isms of Art*), 1925
Illustrated original board,
25.7 x 19.5 cm (10 x 7¾ in.)
Publisher: Eugen Rentsch
New York, Museum of Modern Art
Gift of the Judith Rothschild Foundation.
Acc. n.: 279.2001

A showpiece of typography: characters and numerals are distributed across the surface of the front cover, magnified or in miniature, as individual letters or in their combinations as words. As we gradually make sense of this strange Concrete Poetry, we discover that it is about catchwords of aesthetic modernism. It is – as the left side of the page informs us – about art (*Kunst*). And as we learn from the right-hand side, it is about terms formed with the ending -ism. We thus find ourselves in the middle of the verbal fencing of the avant-garde. The dates 1914 and 1924 vehemently assert the contemporary nature of the -isms named: Constructivism, Dadaism, Suprematism, Cubism and so on.

On opening, the slender volume with the striking cover becomes a book. It starts by fleshing out the concepts in words, either in short quotations from leading representatives of the individual "isms," or in a paragraph composed by one of the editors. These texts are presented in German, French and English, with each language assigned its own column on the page. Next comes a plate section, in which the manifesto-like positions are illustrated by a selection of works. After 48 pages the job is done: a first inventory has been created of the artistic trends, each seeking to outbid the other, that characterize the 20th century. Barely had one camp been established before its opponents were already announcing something even newer, more dynamic and more irresistible.

The two editors El Lissitzky and Hans Arp played their own part in the ongoing succession of artistic trends. The first from a Russian Jewish background, the second from the Alsace, neither is reducible to the single location of Berlin. The isms they present in their short review likewise extend across the whole of Europe. Pictures by George Grosz and Otto Dix can be admired under the heading of Verism, while Raoul Hausmann and Hannah Höch appear along with others under Dadaism. A particular swipe is taken at Expressionism, about which Arp makes the following, cutting comment: "From Cubism and Futurism has been chopped the minced meat, the mystic german [sic] beefsteak: Expressionism." Other isms come off better, especially those to which the two editors felt they belonged. At the end of the day, both were also directly involved in the eternal battle fought by the avant-garde. That Lissitzky and Arp disagreed violently while working on their small dictionary and subsequently remained enemies for life, needs no further explanation.

What remains is a shining example of book design, created by Lissitzky, that stands paradigmatically for the modernist aesthetic. A few hundred kilometres from Berlin, the Dessau Bauhaus will similarly work on an abstract, two-dimensional and succinct style and write design history. What likewise remains is a souvenir of the many émigrés that Berlin attracted during its golden era, who lent the city an extra cosmopolitan flair. In 1920 Hans Arp took part in the *First International Dada Fair*, a celebration of provocation and mockery of the middle classes born out the pacifistic spirit of Dada. And in 1923 Lissitzky conceived his *Proun environment* for the *Grosse Berliner Kunstausstellung*. It was a first demonstration of what we today call an installation: typography can be used in a book – and it can also become architecture. RM

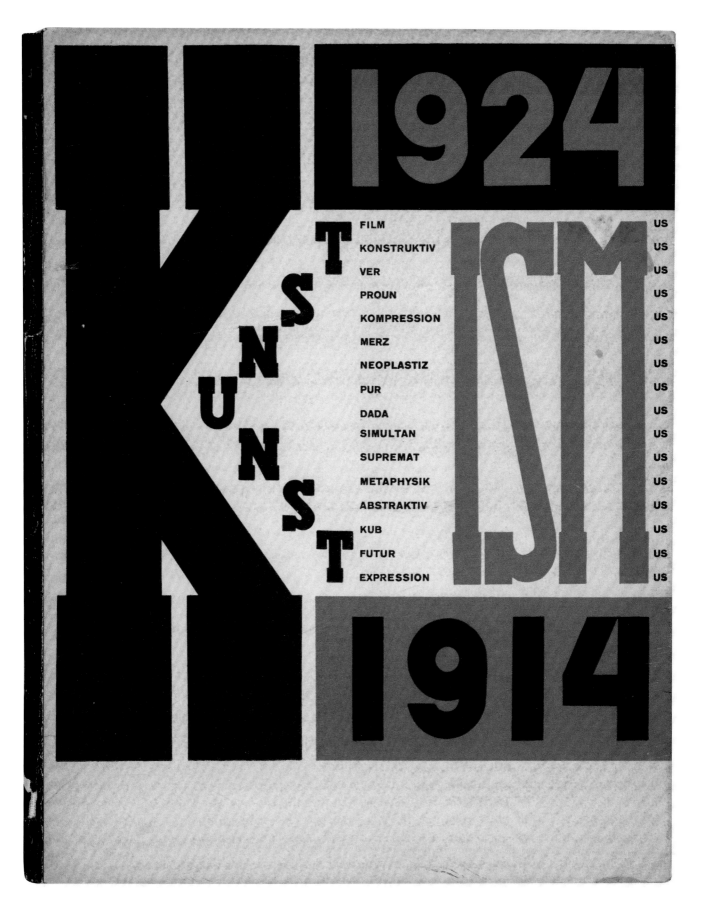

Hannah Höch
The Journalists, 1925

With her growing distance from the Berlin Dadaists, and in the wake of her separation from Raoul Hausmann, Hannah Höch developed new techniques. "It is not possible in her case," writes Susanna Partsch, "to speak of specific phases." In contrast to the majority of Dadaists, who in any case formed a very disparate grouping, she was concerned – like Hans Arp and Kurt Schwitters (1887–1948) – with more than provocative anti-art. But Höch appreciated the Dadaists' embrace of multi-mediality and played a major role in establishing photomontages and collages as art forms. They offered a particularly effective means of holding up a mirror to society, because their material was drawn from publications in contemporary circulation.

Heads and bodies are a striking feature of Höch's œuvre as a whole and are often represented in a grotesque, extremely alienated manner. Even if the women in her 1919 montage *Incision with the Dada Kitchen Knife through Germany's Last Weimar Beer-Belly Cultural Epoch* (ill. p. 35) on the whole represented positive forces of modernism, Höch's interrogation of the intact human figure is by no means confined to men. She created "exceptionally enlightening caricatures of society," to cite Ralf Burmeister. Höch was not the only artist in whose œuvre the fragmentation and deformation of the human body, and equally the humanization and animation of machines, drew attention to the ills of society; it was a characteristic of the art of the epoch.

For *The Journalists*, Höch retained the collage as art form but transferred the technique to the medium of oil painting. She only executed four such works: in addition to *The Journalists*, it is worth mentioning *Roma*, in which Höch confronts Asta Nielsen with the Italian Fascist Benito Mussolini (1883–1945), who is expelling the actress from the city of Rome with an emphatic gesture. "Hannah Höch was no doubt conscious of the striking impact [of such paintings]," writes Karoline Hille, "but she felt 'uneasy' about imitating her own photomontage style and even considered it 'inadmissible,' as she later noted in the draft of an unpublished text." The formal principle of montage as oil painting further contributes to the alienation of the persons depicted. The journalists' heads and bodies exhibit overly large sense organs, giving one figure in particular the appearance of an insect. Höch creates a picture within a picture, as implied not just by the painted frame but also by the title of the oil painting – in German *Journalisten* – which seems to be pinned onto the canvas like a scrap of paper to a noticeboard. The discrediting of the journalists is further reinforced by the fact that these men are hybrid creatures: the bearded figure on the right is wearing women's shoes.

In 1937 *The Journalists* earned Hannah Höch the accusation of "cultural Bolshevism" from the National Socialists, who banned her from exhibiting. She had touched a raw nerve, for under the Weimar Republic the conservative press in particular played a not insignificant role in attempts to undermine the democracy. Alfred Hugenberg's (1865–1951) media company controlled a good half of the contemporary press. In 1926, one year after Hannah Höch, George Grosz took up the same theme in *The Pillars of Society* (ill. p. 63) and characterized the journalist with a blood-soaked quill. UZ

The Journalists, 1925
Oil on canvas, 86 x 101 cm (34 x 39¾ in.)
Berlin, Berlinische Galerie,
Landesmuseum für Moderne Kunst,
Fotografie und Architektur

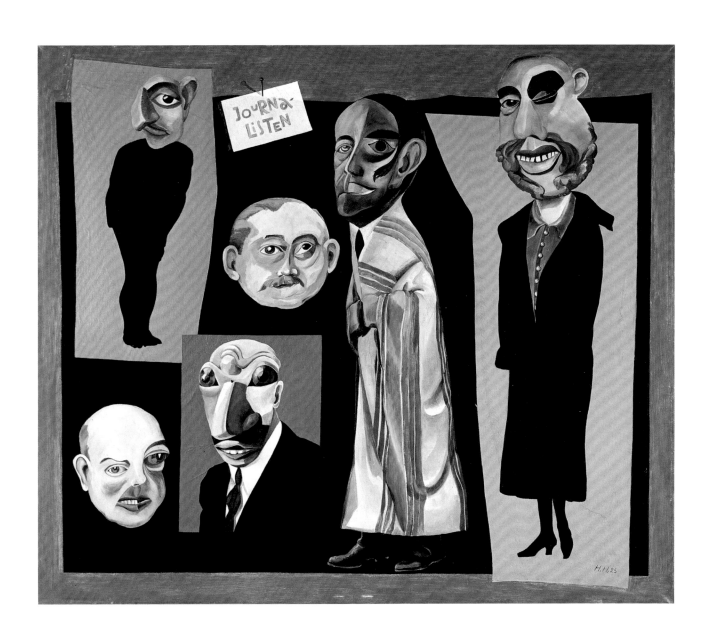

Ludwig Meidner
Portrait of Lotte Lenya, 1925

b. 1884 in Bernstadt a. d. Weide (Bierutów)
d. 1966 in Darmstadt

"And a ship with eight sails, / And with fifty canons, / Will lay by the docks…" For Lotte Lenya (1898–1981), the ballad of Pirate Jenny from Bertolt Brecht's *The Threepenny Opera*, of which these three lines form the refrain, would become synonymous with her career as a singer and actress. Premiered in summer 1928 at the Theater am Schiffbauerdamm in Berlin (ill. p. 18), the songs performed in the play became enormously popular after they were recorded in 1930. Germany was gripped by "Threepenny fever," for which much of the credit went to Lenya: she captivated the public with the inimitable presence of her interpretation, building upon the tension between despondency and determination in her delivery.

Lotte Lenya refused to sing "prettily" right from the start, but Brecht recognized at an early stage her ability to use her voice to lend character to her role. Lenya once again demonstrated her extraordinary gifts as an actress in Georg Wilhelm Pabst's film version of *The Threepenny Opera*, released in 1931. There she convincingly portrays the character of Jenny in all her contradictory states of mind.

In 1925, the year in which Lotte Lenya had her portrait painted by Ludwig Meidner, her career had not yet taken off. Born as Karoline Wilhelmine Charlotte Blamauer in the Vienna working-class district of Penzing, the actress had arrived in Berlin in 1921, already using her stage name. Lenya, who was also moderately talented in ballet, had previously studied in Zurich, where she had gained early experience in minor roles at the Stadt-theater. Even if Berlin, as the journalist and art critic Karl Scheffler famously observed, was damned to an endless process of becoming but never to being "finished," and for that very reason attracted people who were ready to embrace change as a constant and who wanted to develop their creative talents, the city had not been waiting for Ms Blamauer, alias Lenya. She had great difficulty finding work and it was only through her acquaintance with the Expressionist dramatist Georg Kaiser (1878–1945), for whose family Lotte Lenya periodically worked as an au pair, that her life took a new turn. Kaiser introduced the actress to Kurt Weill, one of the most important composers of these years – and they fell in love. The couple married at the start of 1926 and embarked on an unconventionally happy marriage, since Lenya continued to insist on her independence, both in terms of space and sexual relationships, and Weill's first love remained music. The following year saw the start of Weill and Brecht's collaboration on *The Threepenny Opera*, whose enormous success over the next five years – until 1933 – brought with it Lenya's own rise.

In Meidner's portrait, little can be felt of the actress's great erotic attraction, which was described by many contemporaries. The painter, who had earlier developed an ecstatically Expressionist style with his *Apocalyptic Landscapes* and was admired for his psychologically intense portraits of the intellectuals of the Weimar Republic, shows Lenya as a woman lost in thought. The hectic pace of his brushwork has clearly slowed down; representation of the sitter corresponds to her poor standard of living. RB

Portrait of Lotte Lenya, 1925
Oil on canvas, 67 x 49.5 cm
(26½ x 19½ in.)
Stadtmuseum Berlin

Bruno Taut and others
Hufeisensiedlung Housing Estate, Britz, 1925–1933

b. 1880 in Königsberg
d. 1938 in Istanbul

"Light, air and sun" was the slogan of the Neues Bauen ("New Building") movement in architecture. Its social reformist goal was to improve the appalling living conditions in Germany's big cities. Simple comfort, but achieved with the most modern means of industrial construction. The opportunity to implement these methods was presented by the housing shortage that grew ever more acute after the war: by the start of the 1920s, Berlin had need of some 100,000 new apartments.

Out of this urgent situation were born public utility housing associations that propagated the principles of New Building, just like the architects with whom they worked. One such partnership produced one of the most influential housing estates of the 20th century. The Hufeisensiedlung ("Horseshoe Estate") in Britz, built in seven phases between 1925 and 1933, was planned jointly by the architect Bruno Taut in collaboration with the head of the GEHAG housing association and later Berlin chief city planner Martin Wagner, and the landscape architect Leberecht Migge (1881–1935). Taut had made a name for himself with his Glass Pavilion at the 1914 *Werkbund exhibition* in Cologne and became one of the most important architectural visionaries of his time.

In its different parts, the Hufeisensiedlung combines urban elements of New Building and suburban elements of the Garden City movement. At the heart of the complex is the "horseshoe" from which the estate takes its name, and which consists of a row of houses 350 metres (1,148 ft) long and laid out in a curving U-shape. The area inside the horseshoe consists of allotments and a communal green. The horseshoe opens eastwards onto Fritz-Reuter-Allee and thus offers a symmetrically framed entrance to the estate. Leading away to the north and south of the horseshoe are rows of terraced houses (679 homes in total), in whose design Taut took up the ideals of the Garden City movement. Whereas the first terraces to be constructed retained a traditional air, with their tiled roofs and windows with glazing bars, Taut designed the final section in a clearly more urban style: here the industrial style of construction permitted flat roofs and large windows. To the west of the horseshoe, forming the third element of the estate, lay the so-called "Hüsung," whose lozenge-shaped layout recalls a village built around a village green, as found in the countryside around the former Britz manor.

In its combination of echoes of historical tradition with modern means and progressive ideals, the Hufeisensiedlung is considered a milestone of social reformist architecture. As such it forms a counterpart to the conservative Heimatschutz ("heritage protection") style, a rival current in architecture as represented by the Krugpfuhlsiedlung housing estate situated directly opposite. The main difference between the two is Taut's striking use of colour in the Hufeisensiedlung. The façade painted in "Berlin Red" overlooking Fritz-Reuter-Allee was baptized the "Red Front" by the locals. The entrances to the horseshoe, by contrast, are blue. Taut had already issued a call for "colourful building" in 1921, when designing his first housing estate in Magdeburg.

Taut and Wagner both emigrated during the Third Reich. The Hufeisensiedlung survived and in 1986 was classified almost in its entirety as a historic monument. In 2008 it was added to the list of UNESCO World Heritage sites in the category of Berlin Modernism Housing Estates, together with five other housing estates in which Taut was also prominently involved. MN

Hufeisensiedlung Housing Estate,
Britz, 1925–1933
Berlin-Neukölln
View shortly after its completion in 1931

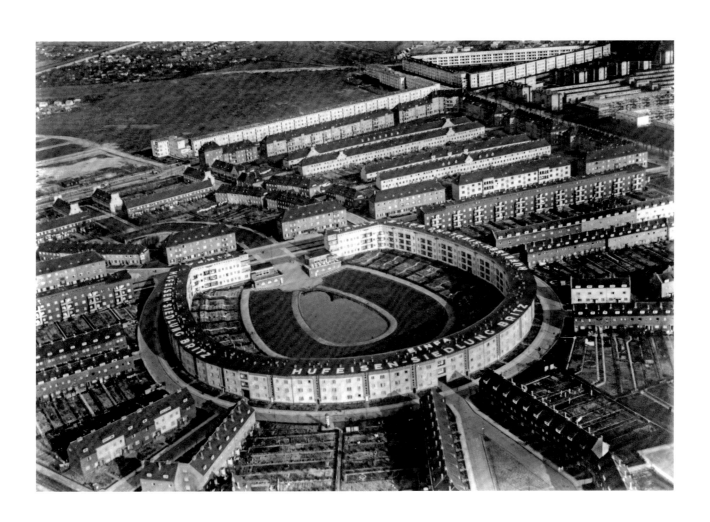

Käthe Kollwitz
City Shelter, 1926

b. 1867 in Königsberg
d. 1945 in Moritzburg

"Spoilt as I now am, if the term 'Käthe Kollwitz' ceased to exist, if the name didn't signify respect and recognition, it would be hard for me to endure. How dreadful artists must feel who are working with no recognition."

— KÄTHE KOLLWITZ, 1925

City Shelter, 1926
Lithograph
Picture: 43.8 x 54 cm (17¼ x 21¼ in.)
Sheet: 53.3 x 75.9 cm (21 x 30 in.)
New York, The Metropolitan Museum
of Art, Harris Brisbane Dick Fund, 1928

"I agree that my art has purpose. I want to be effective in this time when people are so helpless and in need of aid," Käthe Kollwitz declares in her diary in 1922. The desire she expresses "to be effective in this time" is typical of her socially engaged, critical, party-political work with images. From an artistic point of view, no one else in 1920s Berlin embodies as vehemently as Kollwitz the fact that the heart beats on the left. Hers is an art born of feeling, an unwavering declaration of faith, and it is motivated by empathy and concern.

Käthe Kollwitz, who was born in Königsberg, moved to the metropolis with her husband in 1891. She had previously taken private art classes, since the academies were closed to women, and she enjoyed a thoroughly bohemian lifestyle. Her decision to combine her profession with marriage and a family took her into the milieu that would from now on govern her pictorial worlds. Karl Kollwitz was a doctor with a medical practice in Prenzlauer Berg, at that time a fiercely working-class district of Berlin, on the square that today carries his wife's name. Here an endless train of motifs filed past her: sickly children, haggard mothers, men weary of existence – the entire gamut of infirmity and enmeshment that was the focus of the naturalism currently prevailing in theatre, painting and, increasingly, the mass medium of prints. Kollwitz achieved her first major success with her 1893 cycle *A Weaver's Revolt*, inspired by the play *The Weavers* by Gerhart Hauptmann (1862–1946).

She remained faithful to this language. And so the lithograph *City Shelter* looks at the destitution that remained rife at the height of Berlin's glory. Two still very young children are huddled on the ground, tended as best she can by a woman whose face is a picture of misery. She clasps her hand to her forehead in a gesture that simultaneously speaks of melancholy, despair and stupor. Her face seems prematurely aged. There is no trace of comfort for this sad threesome, for the sheet denies them anything that might make life a little less bleak. Hopelessness takes centre stage.

Such documents of silent accusation were sometimes joined by more offensive, challenging, pamphleteering images. An example is Kollwitz's famous poster of 1924, *Nie wieder Krieg* ("Never again War"), in which her own anguish is revealed: her son Peter, like so many of his generation, was called up to fight the French in 1914 and was killed on his second day of duty. Unlike her husband, who was familiar with meaningless deaths from his daily profession, Käthe Kollwitz had supported her son in his enthusiasm to join up. It became the great trauma of her life. And she became a pacifist, the most influential one in Germany.

The immediacy with which she translated her distress into images earned her the nation's highest accolades. She was the very first woman to be honoured with membership of the Prussian Academy of Arts, with a professorship, with the teaching of a master class in graphic art, and with the order *Pour le mérite*. The Nazis naturally saw her as an opponent. She remained in Berlin up to her death in 1945, shortly before the end of the war, soon as helpless and in need of aid as the protégés she had portrayed all her life. RM

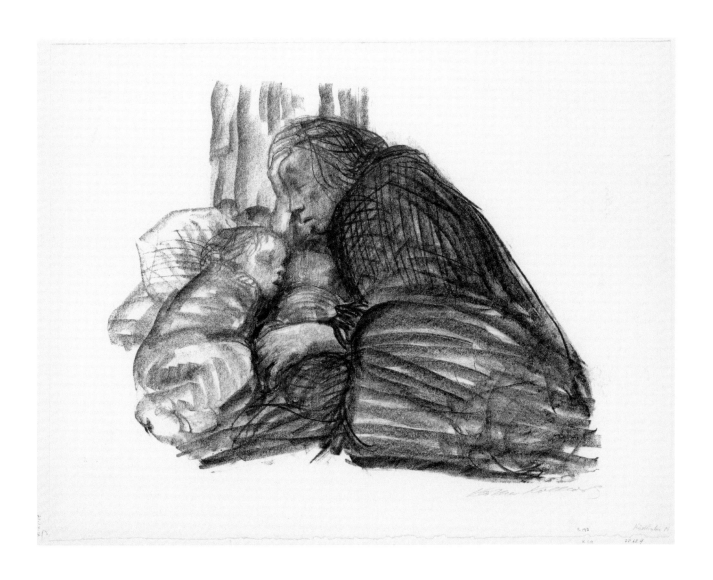

George Grosz
The Pillars of Society, 1926

"We were like sailboats in the wind, with white or black or red sails. Some boats sported pennants with three lightning bolts, or a hammer and sickle, or a swastika on a steel helmet; at a distance, they all looked alike."

— GEORGE GROSZ

"Clarity that hurts" is how George Grosz summed up his artistic creed. For him, art was "not an aesthetic affair" and "not a meaningless end in itself." To hold up a distorting mirror in front of his age, in the form of paintings in which truths are painfully revealed through polemic overstatement – here lay, for Grosz, the "social purpose" of his work as an artist.

In *The Pillars of Society*, one of his major works, George Grosz offers us an exaggerated gallery of typical representatives of power under the Weimar Republic. In the foreground, firmly clasping his beer mug and foil, we see a civil servant with scars on his cheek – earned in a fencing duel – that show him to be an *Alter Herr*, i.e. a senior member of a student fraternity. Without an ear with which to listen, and with an opaque monocle, but already sporting a swastika on his tie, the only thing going through his empty, open-topped skull is the imperial cavalry.

A representative of the press, who bears a striking resemblance to the contemporary media entrepreneur Alfred Hugenberg, is clutching bloodstained copies of the *Berliner Lokal-Anzeiger* and the *8-Uhr-Abendblatt* under his arm. He is ready to launch another biting attack with the sharpened pencil in his hand. The upturned chamber pot on his head covers the intellectual excrement whose stench is already wafting from his neighbour, the vilifying portrait of a Social Democrat parliamentarian. With the old red, white and black imperial German flag in his sausage-fingered hand, on his chest he flaunts a flier with the headline "Sozialismus ist Arbeit" ("Socialism is Work") in retaliation to the Communists' calls for strikes.

In the background, grimly determined with gritted teeth and jutting jaws, are the German military. With its murders of Rosa Luxemburg and Karl Liebknecht, the Reichswehr had already made a bloody contribution to the crushing of the Spartacist uprising in 1919. Lastly, with a gesture of blessing rather than lament for the burning façades, is the clergy. Grosz exposes the nationalistic attitudes of all of these – only supposedly – *Pillars of Society* and caricatures a thoroughly morbid system through their figures.

In reaction to the traumatic experiences of the First World War, George Grosz had already brought his anguished, deeply cynical thinking to Berlin Dadaism and helped make it a "Propagandada." Whether in his collages, drawings, prints or Verist paintings under the New Objectivity umbrella, to which *The Pillars of Society* stylistically belongs, his œuvre is hallmarked by a fiercely attacking, left-wing political stance. He was summoned to appear in court on several occasions to answer charges of "slandering the army," "disseminating lewd images" and "blasphemy." The priest who betrays Christian values and, behind a nationalistic veneer, metaphorically spews out shells and canons from the pulpit, is one of the regular cast in the pacifist Grosz's images.

Knowing that there was nothing left for him in Germany, Grosz left Berlin for New York shortly before Hitler seized power. On 8 March 1933 he became one of the first opponents of the Nazi regime to have his German citizenship officially revoked. In 1937 four of his paintings – seized from public collections – were pilloried as part of the infamous Nazi exhibition of Degenerate Art. RB

The Pillars of Society, 1926
Oil on canvas, 200 x 108 cm
(78¾ x 42½ in.)
Staatliche Museen zu Berlin –
Preussischer Kulturbesitz, Nationalgalerie

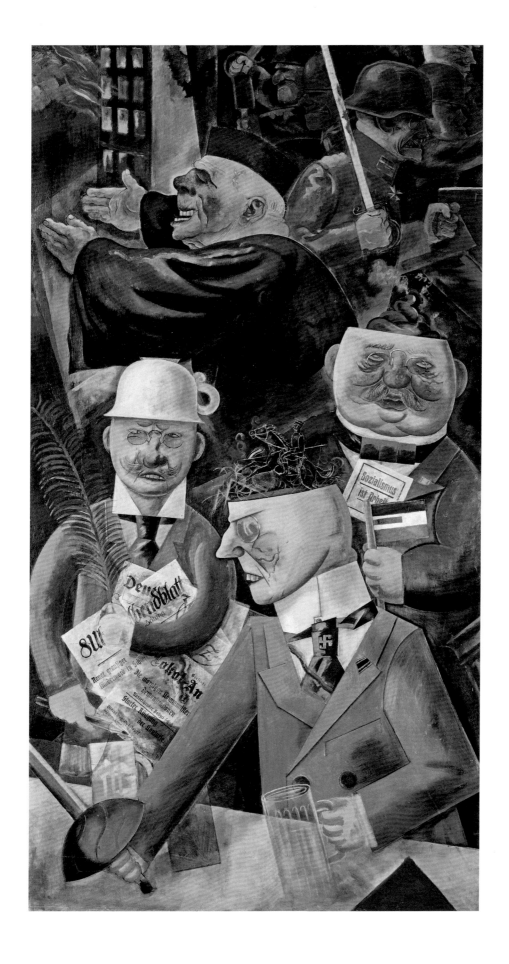

Otto Dix
Portrait of the Journalist Sylvia von Harden, 1926

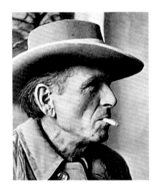

b. 1891 in Gera
d. 1969 in Singen

"When you paint someone, if at all possible you shouldn't know them… I only want
to see what is there; the outside. The inside follows by itself: it is mirrored in the visible."
This statement by Otto Dix is particularly applicable to the portraits he produced while
living in Berlin from 1925 to 1927. Still only in his mid-thirties, the artist built up an excel-
lent reputation in the lively metropolis. His keen powers of observation, the Old Masterly
sophistication of his technique and his unembellished, at times caricaturing manner
of representation captured the mood of the day.

The shockwaves still reverberating from the Great War inspired an art that wanted
to "get closer to life" again, as the novelist Alfred Döblin put it. Frenzied Expressionism
was countered with a return to tangible reality, to clarity and order. This New Objectivity
appeared in so many guises, however, that it is today difficult to speak of a uniform style.
Otto Dix belonged, like George Grosz, to the representatives of Verism. The Verists were
less concerned than the Magic Realists with the meticulous, almost photographic repro-
duction of reality. Using paintbrush and palette, they wanted to get behind visible appear-
ances – whether of individuals or social conditions – in order to lay bare their essence.
In a similar fashion to the Dadaists, at whose *First International Dada Fair* in 1920 Dix
had shown his hard-hitting painting *War Cripples (45% Fit for Service)*, he frequently
deployed heightened exaggeration, pointed concentration or deliberate distortion of
what he saw before him. He does the same thing in his *Portrait of the Journalist Sylvia
von Harden*.

The flamboyant sitter (1894–1963) with the hard face and striking bob was known
in the Weimar Republic less as a journalist than as a – moderately successful – writer and
poetess. She was a regular customer at the Romanisches Café on the Kurfürstendamm,
a popular meeting place for artists. It is here that Dix shows her, seated at a table in a
quiet corner, where it is unclear whether she is talking to someone we cannot see sitting
opposite her, or is simply watching the people around her. With a lit cigarette in her strik-
ingly large, spider-fingered hands, a gleaming monocle on her cocaine-pale face, and at-
tired in a dress in the latest fashion, whose cut and chequered pattern conceal all femi-
nine curves, the woman with the androgynous air undoubtedly presents a striking figure.
The painter underlines the presence she radiates via his use of colour: the red of her dress
extends across the whole room, as everything takes on its hue.

Dix also plays skilfully with the symbolism of the colour red, which switches continu-
ously between lust and aggression. The stocking that has slipped down her leg and can
be glimpsed below the hem of her dress suggests immorality, while the garish lipstick and
expansive gesture of her arm signal aggressiveness and self-confidence. Just as Otto Dix
succeeds in conveying an explicit sense of the sitter's personality solely by heightening her
outer appearance, so his view of the emancipated New Woman as something menacing
and demonic is also implicitly revealed. RB

*Portrait of the Journalist
Sylvia von Harden*, 1926
Oil on panel, 121 x 89 cm (47¾ x 35 in.)
Paris, Musée national d'art moderne,
Centre Georges Pompidou

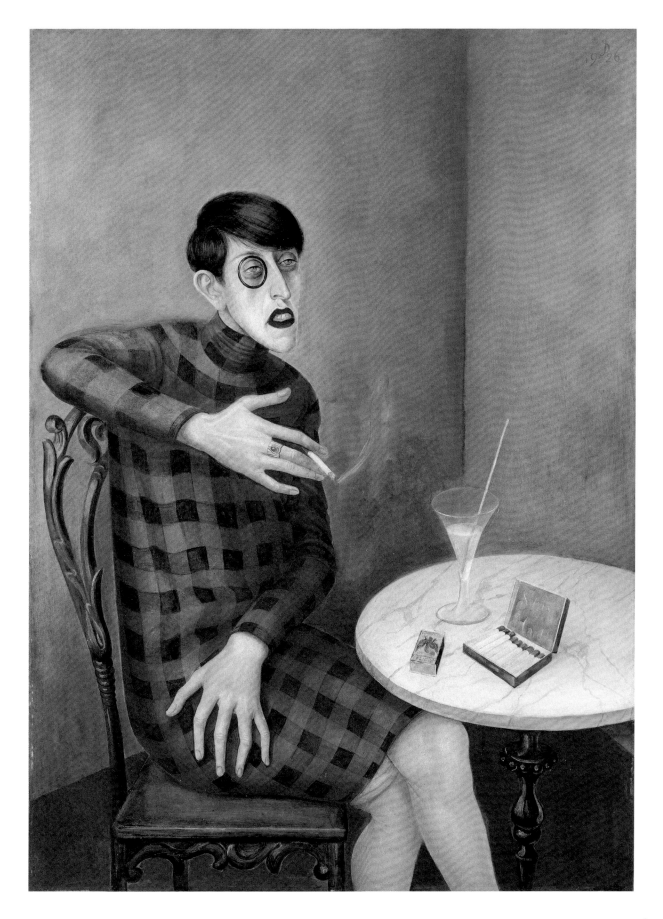

Karl Hofer
Tiller Girls, before 1927

b. 1878 in Karlsruhe
d. 1955 in Berlin

"It began with the Tiller Girls. These products of American 'distraction factories' are no longer individual girls, but indissoluble female units whose movements are mathematical demonstrations." In the opening lines of his 1927 essay *Das Ornament der Masse* (published in English as *The Mass Ornament*), Siegfried Kracauer betrays more fascination than outrage. Sixteen such girls had the public flocking to the Admiralspalast pleasure palace on Friedrichstrasse in the mid-1920s. The Tiller Girls, who paraded in military order and eroticizing costumes, were named after their founder, Lawrence Tiller (confusingly, there was a second troupe of the same name, called after the impresario John Tiller). Their bodies dissolved into ornament as, drilled to precision and in strictly uniform dress, they performed in seamless coordination. And ornament dissolved into bodies when the girls, with their fashionable bobs, tantalizingly long legs and tight-fitting bodices, broke through anonymity and charged it with sexuality.

Karl Hofer examines two of them. If the title didn't tell us so, there would be nothing about them to make us think of the Tiller Girls. Even if the setting in Hofer's picture cannot be recognized, we must assume a situation before or after the actual performance. The girls are seen backstage, for visitors to the variety theatre never saw them so naked or so near. Hofer is neither a photographer nor a journalist; he is a painter. And so he stations himself right in front of the girls, as if they are models in the studio whom he can dress and pose. Were it not for their haircuts and make-up, the two classical female nudes would exhibit all the signs of timelessness.

Karl Hofer, born in Karlsruhe, moved to Berlin before the start of the First World War. Here he established a very successful career as a painter: he became a Secessionist, an academy professor and a member of the most prestigious artistic body of the day, the Prussian Academy of Arts. In 1933 he was dismissed from every position and in 1937 found himself included in the defamatory Degenerate Art exhibition. Rehabilitated after the Second World War, he contributed to the renewal of the Berlin Kunstakademie and died as a figurehead of modernism in Germany: an exemplary career.

According to an anecdote from the same period during which Hofer was scrutinizing the *Tiller Girls*, Pablo Picasso introduced himself to his future lover Marie-Thérèse Walther (1909–1977) with the following words: "Excuse me, mademoiselle, I'm Picasso and I'd like to paint you." We can imagine Hofer invoking the same artist's privilege. He, too, was allowed closer on the grounds that he was painting their portrait. And which of the girls would have turned down the invitation to step out of her uniform and her uniformity? So they submit to the close-up. The fact that, even in so doing, they exhibit only a very little individuality may be due in part to the artist: Hofer is known for his powerfully expressive, large-eyed faces, which always seem to carry a hint of accusation while nevertheless revealing little of the person behind. This faint sense of individuality is also – and above all – a reflection of the spirit of the age, with its penchant for a certain conformation, automatization and democratization. RM

Tiller Girls, before 1927
Oil on canvas, 110.1 x 55.6 cm
(43¼ x 22 in.)
Kunsthalle Emden, Henri and Eske
Nannen Foundation, and donation
from Otto van de Loo

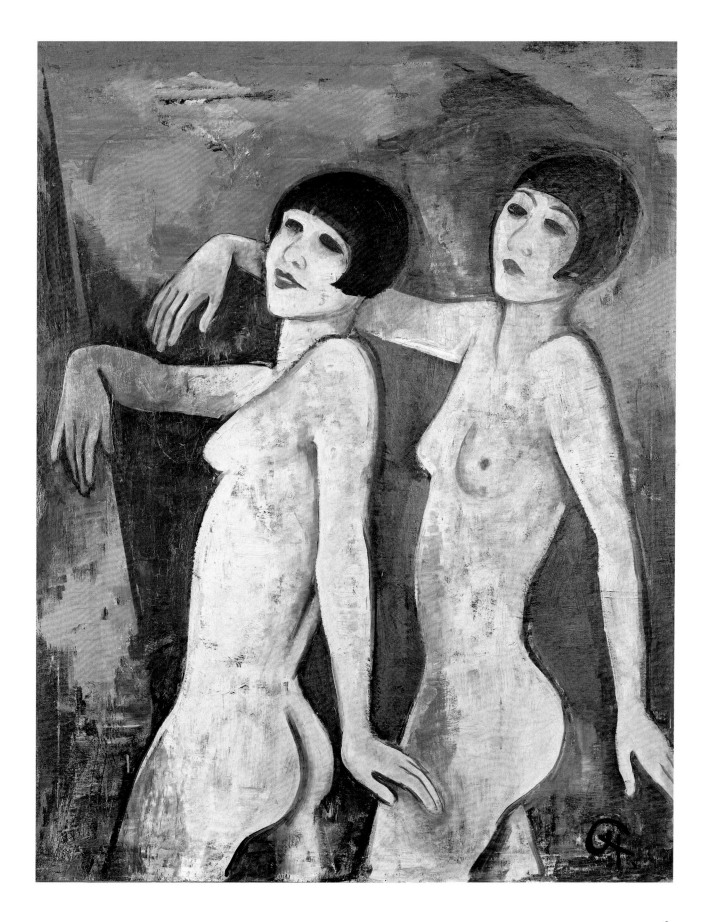

Fritz Lang
Metropolis, 1927

b. 1890 in Vienna
d. 1976 in Beverly Hills

Metropolis, the silent film by Fritz Lang, encountered a chiefly negative reception from critics and the public upon its release in 1927. Today, as the earliest example of German science-fiction cinema, it ranks among the classics of all time. It was the first film to be included on the UNESCO Memory of the World register. Lang's lavish production was made in the UFA studios in Babelsberg; the screenplay was written by his wife Thea von Harbou. In 2010 the restored, complete version was shown at the Berlinale film festival for the first time.

In *From Caligari to Hitler*, his 1947 study of German films made during the Weimar Republic, Siegfried Kracauer describes *Metropolis* as representative of the "paralyzed collective mind" that had helped Hitler to power – an assessment coloured by the influence of emigration and war. The press, however, was particularly critical of the film's ending, which propagated a scarcely credible compromise between the social classes: an appeal to the heart that was bound to seem dubious after the apocalyptic imagery that had gone before.

Lang addressed the theme of the metropolis, and the accompanying problems of the urban masses and criminality, on repeated occasions in the 1920s and 1930s. In *Metropolis*, motifs such as Moloch and the Tower of Babel drew upon popular fears. The spectacular architecture, with its skyscrapers and ultra-modern means of transport, was designed by Otto Hunte (1881–1960), Erich Kettelhut (1893–1979) and Karl Vollbrecht (1886–1973) and was consciously inspired by New York, which had greatly impressed Lang on a visit to the US. A two-class society lives in his *Metropolis*, the city of the future: directed by capital (the "head") with its absolute will to rule, the exploited masses (the "hand") lead a life dominated by machines. Lang employs a complex cinematic language that combines, among other things, religious motifs (including Death and the Seven Deadly Sins), the aesthetic of Expressionism and the technique of collage.

The film, which makes massive use of special effects, reflects the themes of the day, whereby the machines primarily dictate the rhythm of modern life. Examples include the erotic dance performed by the robot Maria, which is followed by a collage of the voraciously fixed eyes of the watching men; the explosion of one of the machines; and the choreography of a change of shift. Speaking of the aesthetic dominance of the machines, which determines life in *Metropolis*, Anton Kaes observed: "Through the way in which the images of machines and the urban landscape overlap at the start of the film, the unalterable precision and energy of the city are made clear."

It was these aspects that the graphic artist and illustrator Heinz Schulz-Neudamm (1899–1969) sought to convey in his design for the film poster, original copies of which today fetch some of the highest prices on the market. Information about the film plays only a subordinate role. Alongside the title, the focus falls instead upon two key elements of the film: firstly, the head of the robot Maria who leads the workers astray and threatens to plunge them into disaster; and secondly the industrial-looking outlines of a futuristic skyline, which presents itself as a cathedral of modernism. *Metropolis* is the smoothly running, soulless city of machines. The featured film still provides an insight in this metropolis of the future. UZ

Metropolis, 1927
Film still

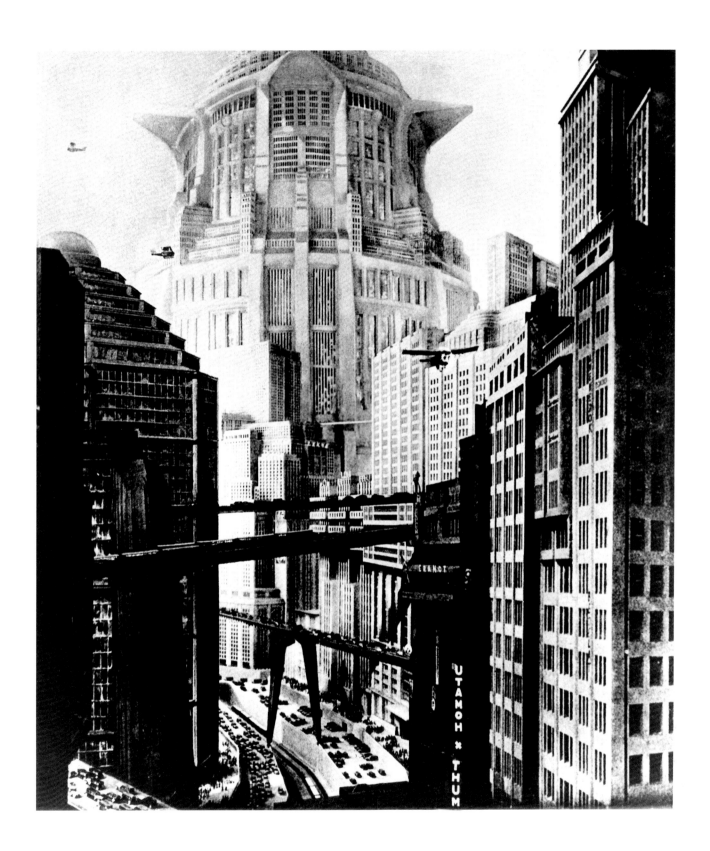

Walther Ruttmann
Berlin: Symphony of a Great City, 1927

b. 1887 in Frankfurt am Main
d. 1941 in Berlin

In the 1920s, not just the subject but also the structures and rhythms of the metropolis were a motif of cinema and literature. The documentary film *Berlin – Die Sinfonie der Großstadt* (*Berlin: Symphony of a Great City*) by Walther Ruttmann, made in 1927 and with a running time of just over 60 minutes, shows life in the capital over the course of a day. Typically for its epoch, the film begins with a train steaming its way towards the metropolis. This train ride is programmatic, not only because it serves to illustrate the vivid difference between countryside and city, but because transport systems – rail tracks, stations, streets – form the fundamental structure of the urban organism. Ruttmann divides his silent movie into five acts. As with all films prior to the introduction of sound, the orchestral accompaniment was a crucial dimension in the viewing experience.

The film concentrates on the permanence of movement. It uses fast cutting to contrast crowds of people with the behaviour of animals, for example. Always subject to the dictates of the clock, men and women have a role to play only for as long as they follow a strict schedule of work and free time. Ruttmann concentrates upon the city's exterior façade: the raising and lowering of shutters, the spinning of machinery, the rotation of revolving doors. This hectic rhythm governs even Berlin's nightlife. Ruttmann associates the line of showgirls in a music hall with the spinning wheels of trains. The documentation is interrupted only when these images dissolve into spiralling movements, illustrating the constant maelstrom of the metropolis. Montages of short texts serve a similar purpose and thrust certain words – such as *Geld* (money) – into the foreground. So too does the brief focus upon a woman committing suicide, whose leap from a bridge interrupts the urban routine.

Ruttmann offers the viewer only a few concrete points of topographical reference. The train arriving into the city in Act 1 terminates at the Anhalter Bahnhof, and Berlin's red-brick city hall – the Rotes Rathaus – can also be recognized. The film ends with a fireworks display at the newly completed Funkturm radio tower. In between, the film is dominated by circular and linear movements: the city as reality on one hand, and dissolving into abstract forms on the other.

The poster (ill. p. 4) alludes directly to the nature of the film: here, too, no specific location is shown. The tall building sliced in two corresponds to the sequence of images and the cross-section that characterizes life in the metropolis. Ruttmann, who studied art and architecture, had made a name for himself at the start of the 1920s with avant-garde experimental films (his four films *Lichtspiel Opus I–IV* were produced between 1921 and 1925), and also as an advertising designer. After 1933 he worked with the actress and film director Leni Riefenstahl (1902–2003), among others.

Film critic Siegfried Kracauer was not convinced by Ruttmann's documentary: "Whereas in the great Russian films, for example, columns, houses and squares are presented with unprecedentedly sharp clarity in their human significance, here we have a series of snippets." In 2002 film director Thomas Schadt (b. 1957) presented a new interpretation of the city in *Berlin: Sinfonie einer Großstadt*, one of many homages to the Berlin of the 1920s – a subject that particularly inspired the arts after Germany's Reunification. UZ

Berlin: Symphony of a Great City, 1927
Film stills

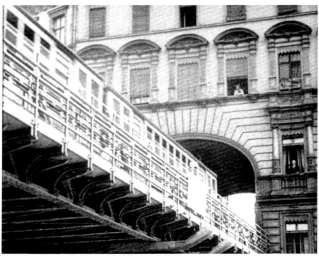

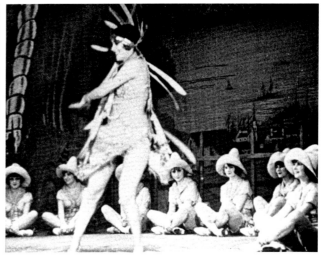

Otto Dix
The Metropolis, 1927/28

"Innovation in painting lies for me, at least, in broadening its subject matter, in amplifying the forms of expression that are essentially already present in the Old Masters. For me, at any rate, the object remains primary and the form is only shaped by the object. Hence the most important question for me has always been whether I am getting as close as possible to the object I am looking at, since the What is more important to me than the How! The How only develops out of the What!"

— OTTO DIX, 1927

A triptych, the three-part panel painting familiar to us from medieval and Baroque altarpieces, and the metropolis as we know it from our own present: it seems that Otto Dix is interested in marrying the old-fashioned with the contemporary. Three panels, therefore. Dominating the left-hand side is a cripple in a style reminiscent of Verism – a figure from the cabinet of horrors created by the war. As he hobbles along on his wooden legs, leaning on his crutches, the still-uniformed ex-soldier is stopped in his tracks. A man lies sprawled on the uneven cobbles, perhaps drunk, possibly beaten up, but seemingly causing not the slightest disruption to the low life flourishing around him. Prostitutes, a brutal face, the menagerie of the underworld – Dix has endeavoured to leave no one out.

Affairs are more social in the central panel, where a jazz band is playing and people are dancing. Judging from the pose of the woman with her hair backcombed as high as the back of her dress plunges low, the rhythm is a Charleston. Jewels jingle to the beat around necks variously thin or fat. Working women, perhaps secretaries, are among those who have come in search of entertainment here – human resources *par excellence* for late-night pleasures. A few bosses also step out to the music in all their manly virility.

On the right, the infernal arrangement of the left-hand panel reappears once again. The cripple has taken off his prostheses and is lying in the corner. The whores now occupy the foreground, parading in curvacious nudity or with the even more curvacious motif of a feather boa over a silk dress. Dix presents its red flounce as nothing other than a grotesquely outsized vagina.

This badge from the arsenal of psychoanalysis is sufficient in itself to show that the artist was concerned with something much more specific, profound and substantial than simply taking a look at the nocturnal sides of the metropolis. He has a pronounced interest in the harsh nature of what goes on in the city by night, but what Dix produces here is the highly ambitious staging of a sort of world theatre. He has painted a triptych. He has taken as his support not canvas but wood panels, as if he were one of the medieval masters he so admired. He has bathed his scenes in a strict opposition of dark alley and bright dance hall, calling to mind the Heaven or Hell hopelessness of Last Judgements. And he has steeped his representation overall in the symbolism of the *memento mori* and the vanity of all earthly pleasures.

Verism's accusatory gestures, motivated by political concerns for the proletariat, give way to a claim to initiation into the abyss of humankind in general and as a whole. The transient is contrasted with the eternal, the momentary with the timeless. When he painted his infernal trinity, Dix had only recently left Berlin. He had accepted a professorship in Dresden so was able to tackle the subject of the metropolis from a distance. What may thereby have increased is not the harsh quality of the representation, but rather the wish to moderate it via references to other phases in art history that were no less vehement when it came to clarity. The shellac record on which he sings the song of his age has a scratch. The record-player arm jumps back, and the accusation is left hanging in the air. RM

The Metropolis, 1927/28
Oil on panel
Middle panel: 181 x 201 cm (71¼ x 79¼ in.)
Wings: 181 x 101 cm (71¼ x 39¾ in.)
Kunstmuseum Stuttgart

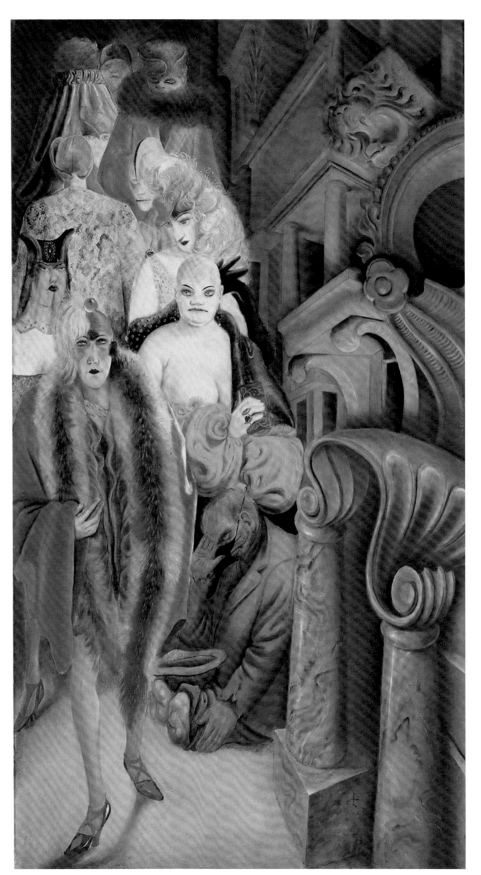

Sasha Stone
Walter Benjamin: One-Way Street, 1928

"Given the slightest opportunity, they form ranks and advance into artillery barrages and department stores in marching order. No one sees further than the back before him, and each is proud to be thus exemplary for the eyes behind. Men have been adept at this for centuries in the field, but the march-past of penury, standing in line, is the invention of women."

— WALTER BENJAMIN, 1928

Sasha Stone (1895–1940), a "photographer between art and commerce" (Birgit Hammers), was from the mid-1920s a representative of the Neues Sehen (New Vision), which responded to the profoundly altered experience of daily life in the post-war years with a break from photographic conventions. Stone trained his photojournalistic lens on the traffic on Alexanderplatz, for example, as well as on industrial buildings such as the Klingenberg power station and on Berlin's popular Sechstagerennen six-day track cycling race. The slogan he adopted for his commercial and industrial photography studio on Berlin's Kurfürstenstrasse was "Sasha Stone sees even more."

By the time Stone opened this studio in 1924, he had already lived in Poland, the US and France. Among the most important works of his Berlin years is a photobook of 1929: *Berlin in Bildern* ("Berlin in Pictures"). But Stone also published regularly in the leading art magazines of the day: *Die Form, Das Kunstblatt, Berliner Illustrirte Zeitung, Der Querschnitt* and *Die Dame.* Stone was a member of the so-called "G" group. The name was derived from the short-lived *Zeitschrift für Elementare Gestaltung* ("Journal for Elementary Design"), an irregular vehicle for discussion by avant-gardists such as Mies van der Rohe, Raoul Hausmann and El Lissitzky, and the primarily Paris-based Man Ray (1890–1976) and Antoine Pevsner (1884–1962).

In addition to his photography, Stone – real name Alexander Sergeyevich Steinsapir – gained a reputation for photographic montages. Montage is a term borrowed from industrial production and is particularly appropriate for Stone's work, since he had trained as an electrical fitter in Warsaw before taking up photography. For the cover of *Einbahnstraße* (translated into English as *One-Way Street*) by Walter Benjamin (1892–1940), in 1927 Stone created a photomontage that repeats the title as a road sign outlined in red against the black and white backdrop of a city street. Benjamin's book was a collection of texts, aphorisms, jokes, dreams and travel memoirs that was not self-contained and which he later continued to expand. Typographically, Stone's repetition of the *Einbahnstrasse* lettering calls to mind other media, such as advertisements and fliers. The montage also does justice to one of Benjamin's central themes: he stylizes the *flâneur* who strolls around the metropolis apparently aimlessly and thereby formulates his impressions as a professional pedestrian. The city of modernism with its wealth of routes and transport links is limited in terms of possible directions – an idea that Sasha Stone playfully adopts when he multiplies the signs pointing to a one-way street.

Stone and Benjamin enjoyed a close friendship. Like Stone, Benjamin was interested in photography and discussed the boundaries and possibilities of the medium in more detail in his 1931 *Kleine Geschichte der Photographie* (*A Short History of Photography*) and his 1935 essay *Das Kunstwerk im Zeitalter seiner technischen Reproduzierbarkeit* (*The Work of Art in the Age of Mechanical Reproduction*). Like so many others, in 1933 Benjamin was forced to emigrate and in 1940 he committed suicide on the Franco-Spanish border escaping from the National Socialists. Stone, in fact an American citizen, was working in Brussels with his wife Cami since the beginning of the 1930s. Like Benjamin, he died on his way to Spain in 1940 while fleeing the Nazis. UZ

Walter Benjamin: Einbahnstraße
(*One-Way Street*), 1928
Photomontage on book cover,
20.4 x 15 cm (8 x 6 in.)
Berlin, Ernst Rowohlt Verlag

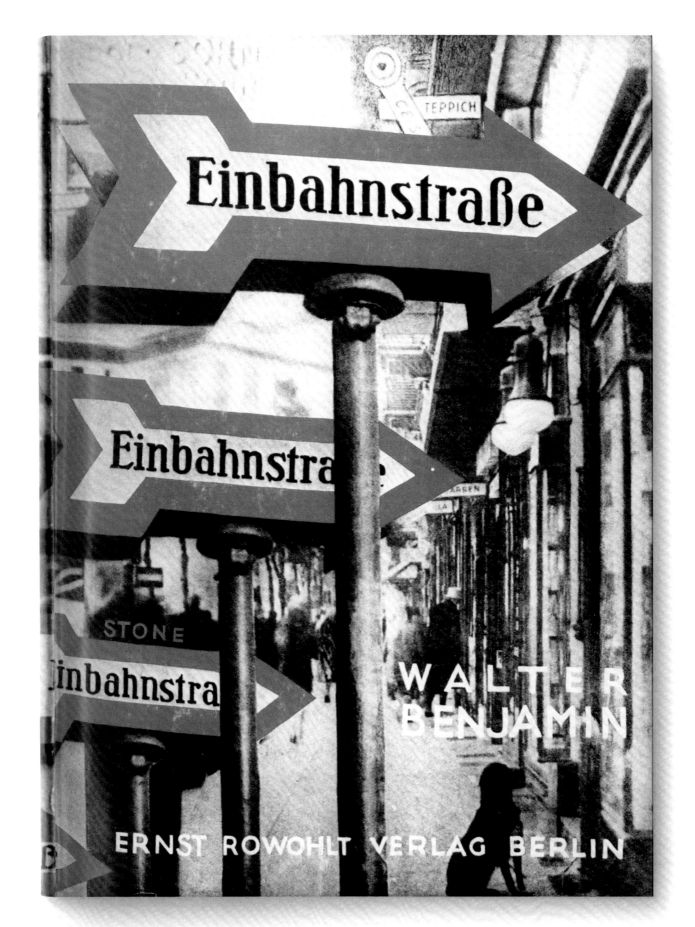

Christian Schad
Portrait of Egon Erwin Kisch, 1928

b. 1894 in Miesbach
d. 1982 in Stuttgart

Neue Sachlichkeit (New Objectivity) was a term introduced in 1925 as the title of an exhibition at the Mannheim Kunsthalle. Christian Schad illustrates in exemplary fashion what it is all about. There is a succinctness, a precision and an incidental quality about the motif, but the whole is nevertheless captured through eyes to a certain extent focused on its negative aspects. Coolness disappears into coldness, realism into cynicism, and the clear gaze assumes a brooding quality.

For this New Objectivity, Schad chooses with exaggerated understatement a very particular subject: Egon Erwin Kisch (1885–1948). Bare-chested, slightly overweight and wearing a mistrustful expression, the man appearing in front of the artist seems to have absolutely nothing of a writer about him. It is true that he is floating up high, but instead of riding on Pegasus he seems to have been hoisted aloft by a sort of crane. He now sits at an airy height and shows off his tattoos, which demonstrate how widely he has travelled. The tattoos appear to come from East Asia and America, and above all from the ships that he used in order to get about. For the man is indeed a writer, even if he tells us plainly with his outer appearance that he is not by nature a poet.

The man is a reporter. In the 1920s that was no longer an obstacle to being considered a man of letters. Kisch is the original "roving reporter" or *Rasender Reporter*, as he titled a collection of his articles in 1924. He rose to fame with another book, *Hetzjagd durch die Zeit* ("Hunting through Time"). Born in Prague, Kisch lived in Berlin from 1921. He was a member of the Communist Party of Germany and a leading representative of that cosmopolitan view of the world in which high culture and subculture mingled in the most natural way. Kisch saw the world from below rather than from above. In that respect, the elevated isolation into which his portrait transports him is wrong.

But then Christian Schad, the painter, tended to add his backgrounds at a later stage. And Kisch does not come across in Schad's picture as some upper-class snob. He looks more like a labourer who is building a modern reality of skyscrapers and steel architecture. Schad, born in Miesbach in Bavaria, had lived in Vienna before he, too, succumbed to the pull of Berlin. He executed Kisch's portrait following his arrival in 1928. These would be his greatest years.

No one captures the blasé, smooth, calculated and invariably slightly indifferent mentality of the metropolis so naturally on canvas as Schad. He becomes a portraitist not just of individuals, but above all of a milieu that thrives on the typically Berlinerish looseness of morals. He paints women from the demi-monde in their demi-monde; he trains his gaze – in a manner that is wholly unpretentious but is also potentially scandalous in its unambiguity – on two naked youths kissing, and he likewise looks at the reality of lesbian love (ill. p. 31). In 1929 the Cologne photographer August Sander (1876–1964) published his book *Face of Our Time*, a collection of portraits that captured 20th-century Germans as types and thus pointed from the individual to the general. Schad fixes such a *Face of Our Time* in the medium of paint. That he does so in Berlin makes his portraiture all the more contemporary. RM

Portrait of Egon Erwin Kisch, 1928
Oil on canvas, 90.5 x 61.5 cm
(35¾ x 24¼ in.)
Hamburger Kunsthalle

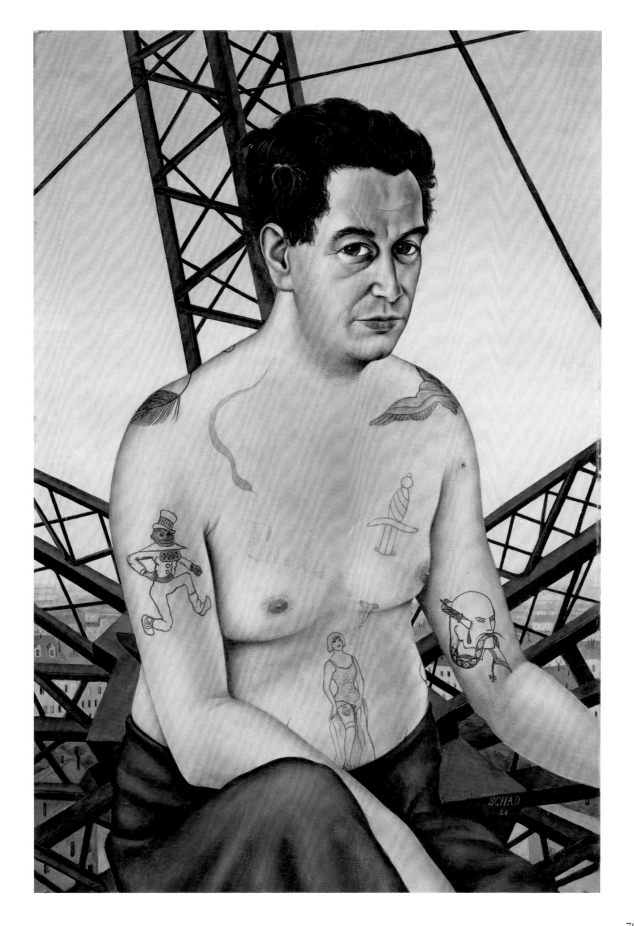

Jeanne Mammen
Revue Girls, 1928/29

b. 1890 in Berlin
d. 1976 in Berlin

Although Jeanne Mammen is considered a solitary artistic figure, her works were nevertheless an almost daily presence in Berlin in the late 1920s. Her drawings and watercolours appeared regularly in the magazines and satirical journals of the liberal intelligentsia, such as *Simplicissimus, Jugend, Lustige Blätter, Ulk* and *Uhu*. Mammen delivered nothing less than a portrait of her times. In the eyes of Kurt Tucholsky, her works transcended by far the "undisciplined scrawling" of so many of her colleagues. In 1929 the prominent publicist made "a little declaration of love" to her in the highly regarded liberal-left weekly journal *Die Weltbühne*. "Your figures," he wrote, "are clear cut with a clean feel, they are gracious yet austere, and they literally jump at you out of the paper."

It was Mammen's *milieu* studies that earned her this compliment. Born in Berlin into a prosperous, cosmopolitan family, Jeanne Mammen grew up in Paris, where she studied painting, and spent further years in Brussels and Rome prior to the outbreak of the First World War. Returning to her native city, she painted and drew the raw reality of the not-so-Golden Twenties – but without infusing her art with the politically propagandist tone of a George Grosz or an Otto Dix. Social criticism emerges in her work in her portrayal of human interaction, which she reproduces in a sober and narrative fashion. Scenes from the world of entertainment on offer in the big city are captured with the same acuity as *petit-bourgeois* couples seeking to escape their daily tribulations for a few hours in a bar or on park benches in Berlin's Tiergarten at night. Mammen portrays high society between shadow and ostentation as well as the sensual, same-sex attraction of women and scenes from the flourishing subculture of the day. The state of society as a whole can be read above all in her representations of faces: almost never cheerful, they are dominated by a masklike expression of boredom, slipping into hopelessness and resignation.

The portrait of two young women, titled *Revue Girls*, also reflects an existential forlornness and introspection. In a position in which they seem to echo each other, the second slightly offset behind the first, the two women each possess a striking, individual profile. Against the darkness of a stage context, however, with their white make-up and glowing red lips and their eyebrows plucked to thin lines, identically dressed with saucy chic in tulle and a fashionable hat, they lose their individuality. Equally unapproachable in their pose, the transparent paleness of their bodies is bound together by a salmon-pink hue that overlies all and indicates their illumination by theatre spotlights. It is true that Mammen does not show us a great number of dancers, but her double portrait captures the essence of contemporary revues: the sensual body was required to function on stage in a modern manner, like a machine, following precise, synchronized movements. In the strictly rhythmical choreography of these popular performances, femininity became a piece of apparatus. The drill this required – "gracious yet austere," as Jeanne Mammen shows it here – left behind a pallid emptiness. RB

Revue Girls, 1928/29
Oil on cardboard, 64 x 47 cm
(25¼ x 18½ in.)
Berlin, Berlinische Galerie,
Landesmuseum für Moderne Kunst,
Fotografie und Architektur

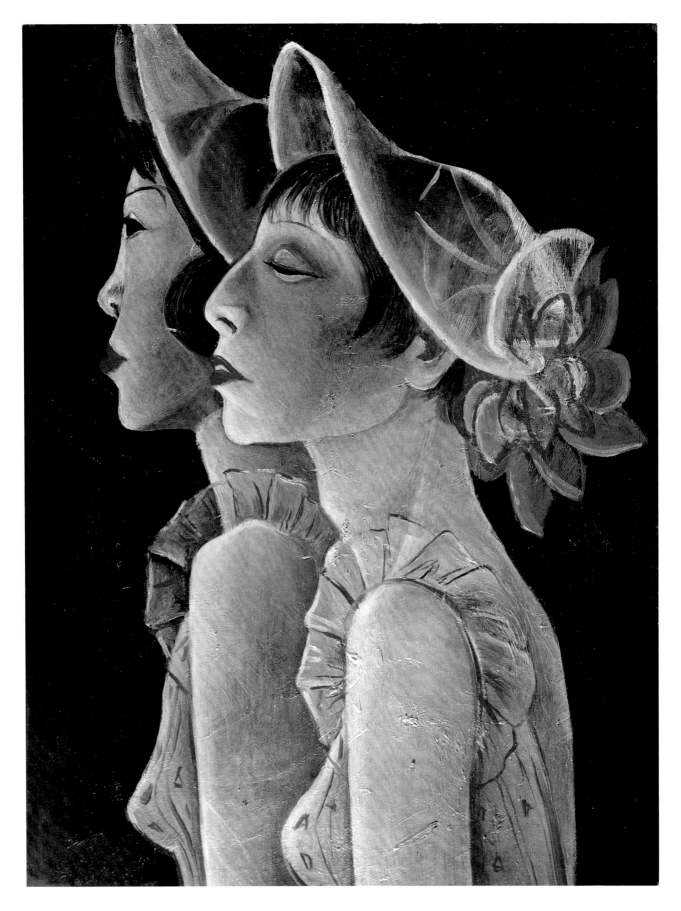

Lotte Jacobi
Hands on Typewriter, 1929

b. 1896 in Thorn (Toruń)
d. 1990 in Deering

"On the dot of nine, 'production' starts. At ten past nine – well rested or tired, it's of no concern to anyone – the girl's slender fingers are already clattering away at the metal keys." In these lines Mascha Kaléko (1907–1975) describes her daily routine. It is true that she is well known as a writer and supplies the Berlin press with poems and prose. But it isn't enough to live on. And so – as she explains in her typically brash style – she sits on her *Popo* (bottom) in a *Büro* (office).

Like hundreds of thousands of others, Mascha Kaléko was a working woman. She was a secretary, performing a very sedentary job, and she therefore had energy to spare for the hours after work. In many cases it was now women who had their evenings free, a fact that shaped the public face of Berlin with the bright glow of its neon signs, its inviting shop windows and ceremonies of cosmetics and couture. The new appeal of the city's glittering exterior also arose out of the needs of a body that had been immobile all day and at some point demanded relief in sport, play and excitement. Berlin's arts and entertainment industry was inconceivable without the businesses that gave people jobs and salaries.

The hands captured by Lotte Jacobi as they glide over the keys of the typewriter are those of a woman. Her own profession, photography, is also in the process of becoming female during these years. She will take over her parents' photography studio at 5, Joachimsthaler Strasse in Charlottenburg and from 1927 onwards build a reputation in her own right. In particular she receives commissions from the many illustrated magazines with a special stake in Berlin's exuberance and mass euphoria. Lotte Jacobi supplies them with images in the new spirit of reportage: the pictures are detailed, focused and concentrated. They zoom in on a single point of interest and screen out the surroundings. They thereby introduce a special economy of attention: for the reader leafing through an illustrated magazine and in danger of being overwhelmed by the onslaught of images, it is a joy to encounter a photograph pared of all excess. With her feel for the decisive detail, Lotte Jacobi subsequently also became a distinguished theatre photographer.

The sort of clarity that, in aesthetics, avails itself of New Objectivity, now embraces typing. Lotte Jacobi's picture of the keyboard was taken in 1929. The shirt, of which we can see only the cuffs of the sleeves, is lily white and has a unisex touch typical of the epoch. The embrace by one gender of the other's style of dress, so prevalent in Berlin, is explained not least by the situation in the workplace, where women are increasingly present alongside men. Everything here seems to be business as usual; what might upset normal operations is methodically screened out. But 1929 is also the year in which this fragile order starts to fall apart. The global economic crisis sets in. Mascha Kaléko sums up what it means for employees in a "Zeitgemäßer Liebesbrief" ("Contemporary Love Letter") published in 1931 in the newspaper *Welt am Montag*. Loosely translated, it reads: "Leaving certificate. The career gently reposes. / Last act. The iron curtain falls, / for instead of the secretaries my boss / has simply suspended payment." RM

Hands on Typewriter, 1929
Vintage glossy gelatin silver print,
16.6 x 22.5 cm (6½ x 9 in.)
© The Lotte Jacobi Collection,
The University of New Hampshire

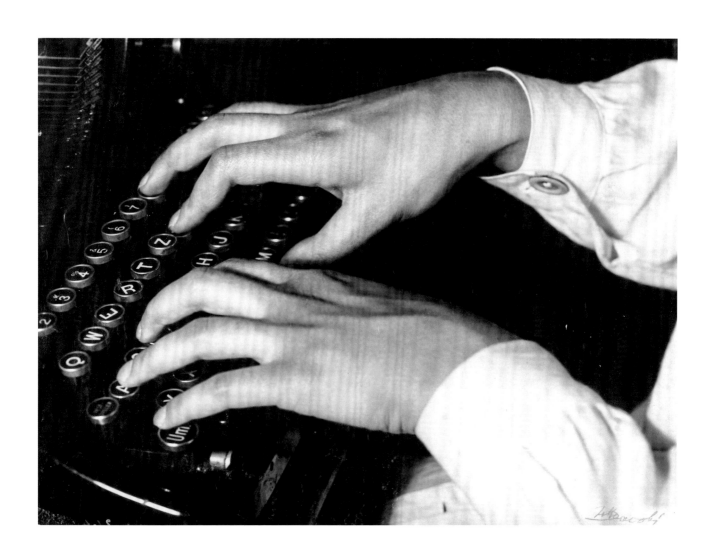

George Salter
Alfred Döblin: Berlin Alexanderplatz, 1929

b. 1897 in Bremen
d. 1967 in New York

"Franz pushed inside. Right now it was the intermission. The long room was packed… Then it gets dark and the film starts. A goose-girl is to be given an education, just why isn't clear, at least not when you come in right in the middle. She wiped her nose with her hand, she scratched her behind on the staircase, everyone in the cinema laughed. It struck Franz as quite wonderful when the chuckling started up around him. People, free people, are simply having a good time, no one's calling the shots, great, and I'm standing in the middle of them."

— ALFRED DÖBLIN

Alfred Döblin: Berlin Alexanderplatz. Die Geschichte vom Franz Biberkopf (***Berlin Alexanderplatz. The Story of Franz Biberkopf***), 1929
Dust jacket, 23 x 18 cm (9 x 7 in.)
Berlin, S. Fischer Verlag

In 1934 Georg Salter, a German-American set designer and commercial artist, Americanized his first name to George following his emigration from Nazi Germany to the United States. Unlike many other artists and writers who found it hard to make a new start abroad in the 1930s, Salter successfully re-established his career. In 1933 he had been dismissed from his teaching post as head of the Department of Commercial Art at the Höhere Graphische Fachschule in Berlin because of his Jewish origins. In the US, he taught typography and calligraphy at the Cooper Union School of Art in New York right up to his death. He cemented his new reputation above all with his designs for book covers. "A good dust jacket must not be banal but must make an impact in the shop window. It must catch the eye," wrote graphic designer and publicist Eberhard Hölscher (1890–1969) of Salter's art in 1930, making clear how ground-breaking his work was perceived to be.

At the start of the 1920s Salter had created sets for the theatre, and by 1934 he had also worked for 33 different publishers and designed some 350 covers. Authors for whom he provided eye-catching book jackets included Ernst Toller (1893–1939), Peter de Mendelssohn (1908–1982), Egon Erwin Kisch, Arnold Zweig (1887–1968) and Anna Seghers (1900–1983), and later in the US Carl Zuckmayer (1896–1977) and William L. Shirer (1904–1993). Back in 1923 Salter had already proved how greatly his covers could enhance books, while working for the publishers Die Schmiede, for whom he designed the biography of Lenin by Henri Guilbeaux (1884–1938). The cover carries nothing but the name in red lettering: *Lenin*.

Salter's design for the cover of *Berlin Alexanderplatz*, the 1929 novel by Alfred Döblin (1878–1957), proved particularly successful. Salter collaborated directly with the author of one of the most profoundly Expressionist works of the Weimar Republic. Döblin wrote new texts specifically for the jacket, so that as viewers we become readers as soon as we begin studying the cover design, before we have even opened the book. In his essay "Designing Book Jackets," published in 1939, Salter outlined several different categories of cover design. One such category is jackets that communicate the content of the book solely via typography or hand lettering, on which lettering has the power to evoke specific moods. The hand lettering employed in Salter's cover design for Döblin is combined with pictorial elements in a seemingly naïve style, which have been compared with the simple but easily comprehensible illustrations that accompanied ballads. Salter's jacket thereby anticipates aspects of the experience of reading Döblin's novel itself, for in *Berlin Alexanderplatz* the chapter headings comment in detail on the content so that the reader knows exactly what is coming next. In this respect the headings have a similar effect to headlines.

Berlin Alexanderplatz. Die Geschichte vom Franz Biberkopf (subsequently translated into English as *Berlin Alexanderplatz. The Story of Franz Biberkopf*) was serialized in a newspaper from 1928. Following a spell behind bars, Biberkopf makes a vain attempt to lead an honest life. What was new about the novel, which was rapidly turned into a film in 1931, was Döblin's use of literary montage, in which he combined his narrative with adverts, news clippings, biblical quotations, statistics and, in one example, detailed reports from the slaughterhouses. UZ

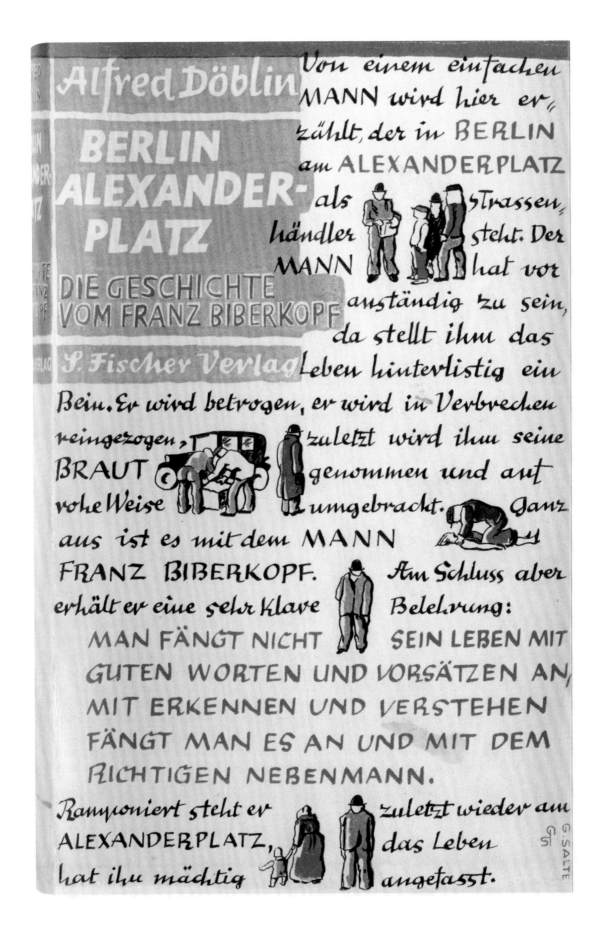

Alfred Döblin

BERLIN ALEXANDER-PLATZ

DIE GESCHICHTE VOM FRANZ BIBERKOPF

S. Fischer Verlag

Von einem einfachen MANN wird hier erzählt, der in BERLIN am ALEXANDERPLATZ als Strassenhändler steht. Der MANN hat vor anständig zu sein, da stellt ihm das Leben hinterlistig ein Bein. Er wird betrogen, er wird in Verbrechen reingezogen, zuletzt wird ihm seine BRAUT genommen und auf rohe Weise umgebracht. Ganz aus ist es mit dem MANN FRANZ BIBERKOPF. Am Schluss aber erhält er eine sehr klare Belehrung:

MAN FÄNGT NICHT SEIN LEBEN MIT GUTEN WORTEN UND VORSÄTZEN AN, MIT ERKENNEN UND VERSTEHEN FÄNGT MAN ES AN UND MIT DEM RICHTIGEN NEBENMANN.

Ramponiert steht er ALEXANDERPLATZ, zuletzt wieder am das Leben hat ihn mächtig angefasst.

G. SALTE

Peter Behrens
Berolinahaus and Alexanderhaus on Alexanderplatz, 1929–1932

b. 1868 in Hamburg
d. 1940 in Berlin

Probably no other public space is as emblematic of the Weimar Republic as Alexanderplatz in Berlin. As the protagonist of the eponymous novel by Alfred Döblin (ill. p. 85) and of Walther Ruttmann's film *Berlin: Symphony of a Great City* (ill. p. 71), the square reveals itself to be the concentrated essence of a time of upheaval, characterized by crowds of people, streams of traffic and subway construction sites.

In the period between the two world wars, Alexanderplatz changed its face almost entirely. Originally just a crossroads on the edge of the medieval Old Town and the starting point of the avenues leading east, by the 1920s the square had reached the limits of its capacity. To prevent the collapse of a key intersection in the city of four million, in 1928 chief city planner Martin Wagner announced an architectural competition for the square's redevelopment. The architects invited to take part were given a brief guideline specifying a large roundabout 100 metres (328 ft) in diameter and a widening of the approach roads to over 30 metres (98 ft).

The winners of the competition were announced in February 1929, with first prize going to brothers Hans (1890–1954) and Wassili Luckhardt (1889–1972). Due to the onset shortly afterwards of the global economic crisis, however, their design was abandoned. Since most of the existing buildings had already been demolished to allow the construction of the subway, a plan to redevelop the square was still urgently needed. The private consortium Bürohaus am Alexanderplatz GmbH put up the funding and Peter Behrens – who came second in the competition – was approved as architect. His plans envisaged two tall gateway buildings with a uniform façade in a strictly vertical grid design, next to Alexanderplatz station. They were followed to the east by a wide square with a semicircular architectural surround and a monumental overall impact.

Only a much reduced version of this design was actually implemented. Solely the two gateway buildings, which Behrens conceived as an architectural ensemble, were completed: the Berolinahaus, erected between 1929 and 1932 on a rectangular ground plan, and the Alexanderhaus, completed between 1930 and 1932 on a Y-shaped ground plan. Both used a contemporary skeleton-frame construction of reinforced concrete. Their ground floors were earmarked for shops, the projecting glazed gallery above for restaurants and cafés. On the outside, the upper office storeys presented a rigorous grid of square steel windows in a shell limestone façade. Inside, paternoster lifts and escalators offered modern, cosmopolitan experiences of space, while the basement featured direct access to the subway.

Peter Behrens was already considered the "father of modernism" by this time. Walter Gropius (1883–1969), Le Corbusier (1887–1965) and Ludwig Mies van der Rohe had all worked in his office before going on to become leading figures in modern architecture in their own right. Behrens himself had risen to prominence primarily with his industrial buildings, which conveyed his vision of architecture as a synthesis of the arts. He designed everything from machine halls to typography for companies such as AEG and is today considered the inventor of corporate design. His Alexanderplatz project testifies to his preoccupation, towards the end of his career, with issues of modern urban development. Thanks to their stable construction, his two buildings survived the devastation of the Second World War – the only ones on Alexanderplatz to do so. MN

View from the south of the Berolinahaus on Alexanderplatz by Peter Behrens
Photograph

View from the north on Alexanderplatz with office buildings by Peter Behrens
Alexanderhaus (left), built 1930–1932
Berolinahaus (right), built 1929–1932
Behind the Berolinahaus
is Alexanderplatz station.
Photograph

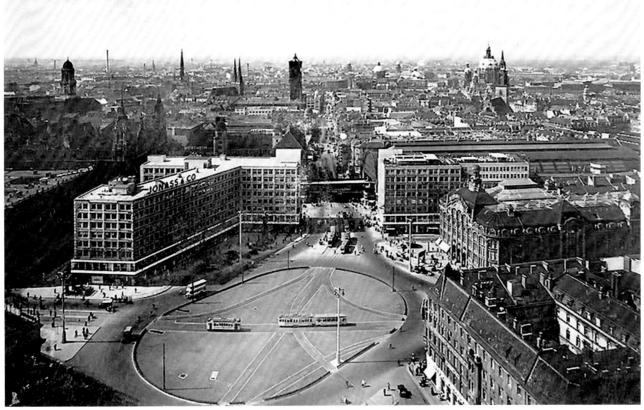

Lotte Laserstein
Evening over Potsdam, 1930

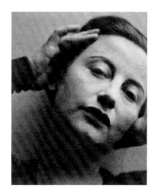

b. 1898 in Preussisch Holland (Pasłęk)
d. 1993 in Kalmar

Dusk is falling over the company at table: wine and beer have been drunk and sufficient words exchanged. Gazes are turned inwards. Tranquillity wanes, for the sky is clouding over. The companions are together and at the same time alone.

The atmospheric painting of five friends gathered on a roof terrace in the city of Potsdam, located just outside Berlin, is considered the most important work by the artist Lotte Laserstein. Calling to mind representations of the Last Supper, this scene characterized by silence and melancholy, set at the transition from day to night, is a symbol of the times. In 1930, the year in which the picture was painted, the global economic crisis had sounded the end of the Golden Twenties. Daily life was governed by uncertainty and resignation as a result of mass unemployment. Whether evening would be followed by a morning bringing something better was less sure than ever.

Lotte Laserstein was one of the first women to be able to hone her artistic talent at Berlin's Kunsthochschule, where she completed her studies in 1927. Admission to art academies was only granted to women in 1919, at the same time as the right to vote. Laserstein was considered one of the "very best of the young generation of painters," as the *Berliner Tageblatt* reported, and a "glittering career" was prophesied for her. Her works are determined neither by the smooth coolness nor by the socio-critical Verism of New Objectivity; Laserstein's brushwork is distinguished instead by an old masterly recording of the visible world. Details – whether the fold of a fabric, individual strands of hair, or even dirt under the fingernails – are reproduced with a precision that falls into the 19th-century tradition of German Realism. The figures in her paintings are entirely contemporary and are taken from her metropolitan surroundings. Laserstein's sitters range from a sportily self-confident New Woman in a white-, blue- and red-striped tennis dress from the upper crust, to the young man in leathers who poses proudly in front of his motorbike in a rear courtyard. In her visual compositions, Laserstein adopts current vocabularies of form and also orients herself towards the stylistic techniques of photography – such as the close-up view filling the entire picture – and of advertising.

The resigned and ominous mood that permeates *Evening over Potsdam* was in a way prophetic of Lotte Laserstein's future. As a Jewish artist, Laserstein was barred from exhibiting from 1933, and in 1937 she managed to emigrate to Sweden. Her mother Meta died in Ravensbrück concentration camp. Lotte Laserstein never returned to Germany. One of her early paintings, purchased in 1927 by the city of Berlin, was impounded as "degenerate." It shows a pensive young woman, wearing a fashionable hat over her short bob, seated in a Berlin café. Crucially, she is on her own, i.e. without male company. Such an image of an emancipated woman must have represented the very opposite of the image of women held up by Nazi ideology. Laserstein's rehabilitation has been a protracted process: rediscovered in Germany since the early 2000s, her œuvre is slowly receiving the appreciation it deserves. RB

Evening over Potsdam, 1930
Oil on panel, 111 x 205.7 cm
(43¾ x 81 in.)
Staatliche Museen zu Berlin –
Preussischer Kulturbesitz, Nationalgalerie

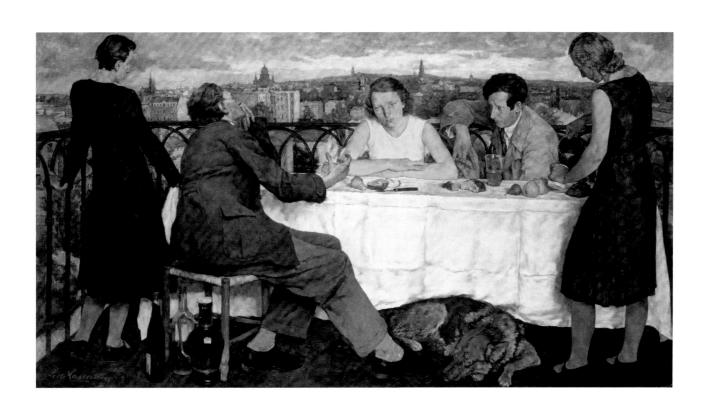

Josef von Sternberg
The Blue Angel, 1930

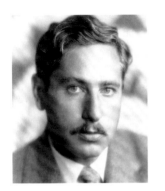

b. 1894 in Vienna
d. 1969 in Hollywood

PAGE 91
The Blue Angel, 1930
Film still

Heinz Bonné
The Blue Angel, 1930
Film poster

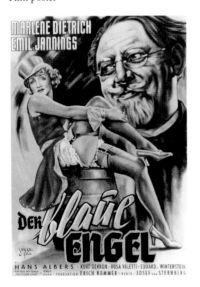

Der blaue Engel and its English-language version *The Blue Angel* were filmed under the direction of Josef von Sternberg and based on the 1905 novel *Professor Unrat oder Das Ende eines Tyrannen* (*Professor Garbage or The End of a Tyrant*) by Heinrich Mann. Actors Emil Jannings (1884–1950), Kurt Gerron (1897–1944), Rosa Valetti (1878–1937) and Hans Albers (1891–1960) were among Germany's leading stars of the 1920s and 1930s. Most importantly, however, the film gave actress Marlene Dietrich her international breakthrough.

Dietrich plays the cabaret singer Lola Lola, for whom the secondary-school teacher Immanuel Rath develops an all-consuming passion. After their marriage, he becomes part of the performing troupe. When forced to return to his home town and *The Blue Angel* cabaret where their affair began, Rath suffers a breakdown. Whereas Heinrich Mann's book, appearing shortly after the turn of the century, was to be understood as an attack on the moral hypocrisy of the middle classes, von Sternberg's film portrays a man who does not adhere to the prevailing norms and is destroyed as a result.

German and English film posters – in which Dietrich became successively more prominent – concentrate on precisely this contradiction: on the one hand, the straitlaced schoolmaster, and on the other the brazen young Lola Lola, with or without her masculine top hat. Lola Lola embodies a quality that was popular in the Twenties: sex appeal. Friedrich Hollaender dedicated an entire chanson to the phenomenon. Hollaender also composed the songs that contributed to the film's success, including the popular hit "Ich bin von Kopf bis Fuss auf Liebe eingestellt." *The Blue Angel* is a multiple-language film that was filmed in English and German versions right from the start, and Hollaender's chanson became "Falling in Love Again."

The acting, the English version and the "coherence and logic of the film" (Dieter Krusche) all contributed to the fact that it became one of UFA's few international successes. Germany lagged a number of years behind when it came to making sound films, but took up the trend as from 1929. *The Blue Angel* benefited from the new technology: after years in which visual effects and montages had dominated the action, cinemagoers were now able to engage with the story in a completely different way.

It proved difficult right from the start to separate the success of the film from Marlene Dietrich's career. "It took years," writes the Vienna journalist Alfred Polgar in a manuscript on the Marlene phenomenon rediscovered in 1984, "before the movies discovered the Dietrich type…, the type of woman 'whose gaze suddenly meets ours like a summons, like destiny, and who seems astonished by what she wreaks' (Franz Hessel) and exploited its unique, perfect embodiment by Marlene."

In his 1930 poster for *The Blue Angel*, commercial artist Heinz Bonné – who subsequently took over the management of the UFA studios in Leipzig, and after the war worked first for the state-owned DEFA film production company in East Germany and then as a designer of promotional material for films in West Germany – highlights the contrast between the young and uninhibited Lola and the older Rath, slavishly devoted to the object of his desire. Marlene Dietrich here clearly stands out in bright colours against Emil Jannings. Dietrich's provocative pose, on which Bonné concentrates, became her trademark: the female body becomes part of the marketing strategy. UZ

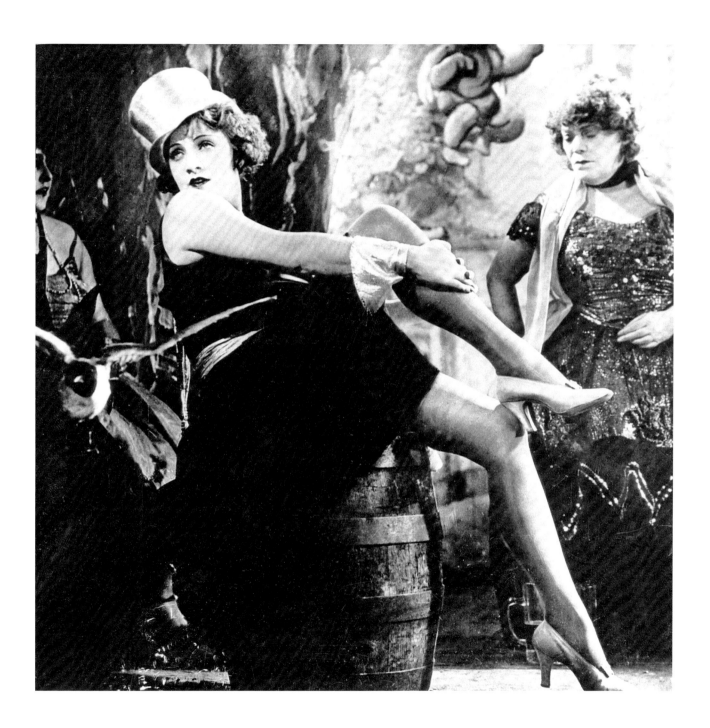

Erich Mendelsohn
Columbushaus, 1931/32

b. 1887 in Allenstein
d. 1953 in San Francisco

Columbushaus, 1931/32
Berlin, Potsdamer Platz
The building was located on the
northwest side of the square and
was demolished in 1957.
Photograph, *c.* 1933

Lined with buildings such as the Potsdamer Bahnhof railway station, Haus Vaterland pleasure palace and Wertheim department store, Potsdamer Platz embodied the metropolitan density and vitality of the Golden Twenties. Crossed by 26 tram lines, five bus routes and 20,000 cars per day, it was Europe's busiest square. In 1924 the famous traffic tower was erected at its centre, carrying the second set of traffic lights to be installed in Germany. At the end of the 1920s, chief city planner Martin Wagner proposed a redevelopment scheme that envisaged larger and taller new buildings and which also incorporated Leipziger Platz, which lay immediately adjacent to the east. The economic crisis meant that Wagner's plans were never implemented, however. With one exception: in 1931/32 a nine-storey block of offices and shops was completed in the northwest corner of the square, on the former site of the Grand Hotel Bellevue, which had been demolished in 1928. The height of this "little skyscraper," named the Columbushaus, was inspired not least by commercial considerations: Wagner's widening of the road had reduced the size of the plot, and so it became necessary to build the leasable floor space upwards in order to keep the project profitable.

The designer of the Columbushaus, Erich Mendelsohn, was at this time one of Germany's most prolific architects. His 1923 extension to the offices of Rudolf Mosse's publishing house in Berlin, and his 1928 Schocken department store in Stuttgart, invoked the urban dynamism of the era with their expressive emphasis upon horizontals. Probably his most famous building is the Einstein Tower (ill. p. 16) constructed in 1918–1924 in Potsdam, whose organic, dynamic forms were entirely new for their da.

The architecture of the Columbushaus was likewise determined by expressive horizontal lines: in its façade, continuous rows of windows alternated with narrow bands of masonry and thereby accentuated the curve of the street at the point where Friedrich-Ebert-Strasse joined Potsdamer Platz. The horizontal line was restated once more at the top of the building in the elegant and slim cantilevered roof over the recessed terrace. The organization of the façade terminated at the bottom in the large windows of the shops. The Columbushaus thus presented an emphatic contrast to the rather more static, vertical divisions of Berlin's established department stores, as embodied for example by Kaufhaus Wertheim immediately next door.

Inside, the Columbushaus reflected the latest state of technology. The steel-frame construction meant that the offices did not require dividing walls and could be freely partitioned. The building's artificial ventilation system was the first of its kind in Germany. Despite this modernity, the Columbushaus had a difficult start: both the commercial premises and the offices stood almost completely empty for the first few years due to the high rents.

In 1933 its architect Erich Mendelsohn emigrated first to Holland and then, via Britain and Jerusalem, to the US. The Columbushaus survived the Second World War with only minor damage, but was set on fire during the workers' uprising of 17 June 1953 in the GDR. In 1957 the ruins, which now lay in the border zone between East and West Berlin, were demolished. Its neighbour, Kaufhaus Wertheim, had suffered the same fate one year earlier. From 1961 the Berlin Wall ran exactly between their two vacant sites. MN

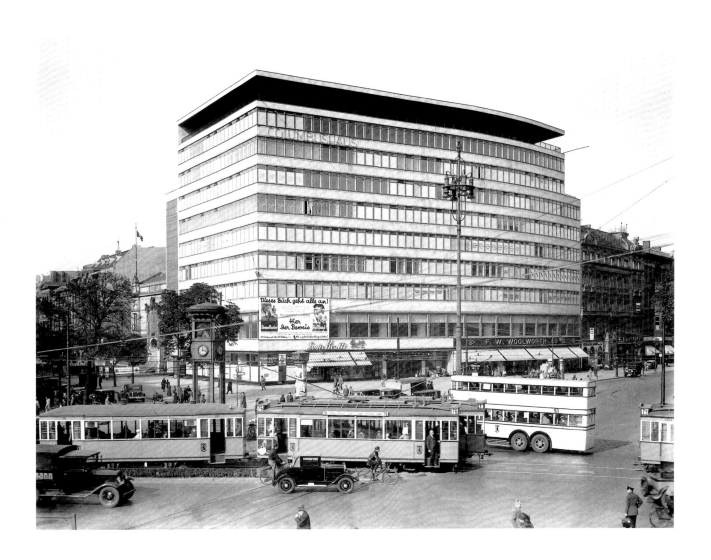

John Heartfield

The Meaning of the Hitler Salute: Millions Stand Behind Me!, 1932

b. 1891 in Berlin
d. 1968 in Berlin

This photomontage by John Heartfield appeared as the front cover of the 16 October 1932 issue of *A-I-Z*. The magazine – in full, the *Arbeiter-Illustrierte-Zeitung* – was founded in 1921 by Willi Münzenberg (1889–1940) and up to 1933 was published in weekly editions of as many as 500,000 copies. Heartfield, a passionate opponent of National Socialism, joined the magazine's staff in 1930. According to journalist Kurt Tucholsky, who occasionally collaborated with Heartfield, by "teaching the reader to see with our eyes, the photo will not merely speak – it will shout." Heartfield's photomontages exploit the break with established visual conventions in order to deliver their message. By cutting out selected parts of photos from the press, rearranging them and captioning them with a provocative title, Heartfield produced an emotional reaction, whether of anger or agreement. These montages require no reading of the small print: their message is as clear as propaganda. For Heartfield – who also designed book jackets for the Malik publishing house set up by his brother Wieland Herzfelde (1896–1988), as well as stage sets – politics and speaking out against militarism had always been paramount concerns: like George Grosz, he had deliberately anglicized his name during the First World War.

Heartfield's technique had profited at the start of the 1920s from his affiliation with the Dadaists and their renunciation of traditional art. In 1920 he took part in the *First International Dada Fair* in Berlin under the name of "Monteur-Dada" (the "Dada Fitter"); it is not the artist but the technician who is here mobilizing social forces, with the emphasis less on aesthetics than on concrete ideas. Just as Bertolt Brecht positioned himself as a "writer of pieces" (German: *Stückeschreiber*) rather than an author (*Schriftsteller*), Heartfield emphasized this pragmatic aspect of his work.

The magazine headline *Der Sinn des Hitlergrußes* (The Meaning of the Hitler Salute) questions the role of the emerging National Socialist party through the fact that Adolf Hitler's hand is receiving millions in banknotes from a faceless but powerful Industry. The capitalist system that stands behind Hitler, and to which the rest of the text refers more specifically ("Little Man Asks for Big Gifts. Motto: Millions Stand Behind Me!") thus takes on a menacing significance. The way in which Heartfield alters the proportions is crucial: the body behind Hitler dominates the "little man" and – for the politically left-wing Heartfield – illustrates the true balance of power in 1932. The reference to the "little man" alludes at the same time to Hitler's attempt to portray himself as the representative of the people. The photomontage was highly topical: in July 1932 the National Socialists had achieved significant election successes and six months earlier, in January, Hitler had delivered a speech to leading industrialists in Düsseldorf. Heartfield took a similar tack in a further montage of 1932: *Adolf, der Übermensch – schluckt Gold und redet Blech* (*Adolf, the Superman – swallows gold and talks tin*) likewise questions the independence and the claims of the National Socialists.

After 1933 Heartfield continued to wage his battle against Nazism from exile – but spent the war years in a British POW camp, before resuming his artistic career after the Second World War in the newly founded German Democratic Republic. UZ

Der Sinn des Hitlergrußes: Millionen stehen hinter mir!
(*The Meaning of the Hitler Salute: Millions Stand Behind Me!*), 1932
Photomontage printed
Arbeiter-Illustrierte-Zeitung (A-I-Z)
Title page, 16 October 1932

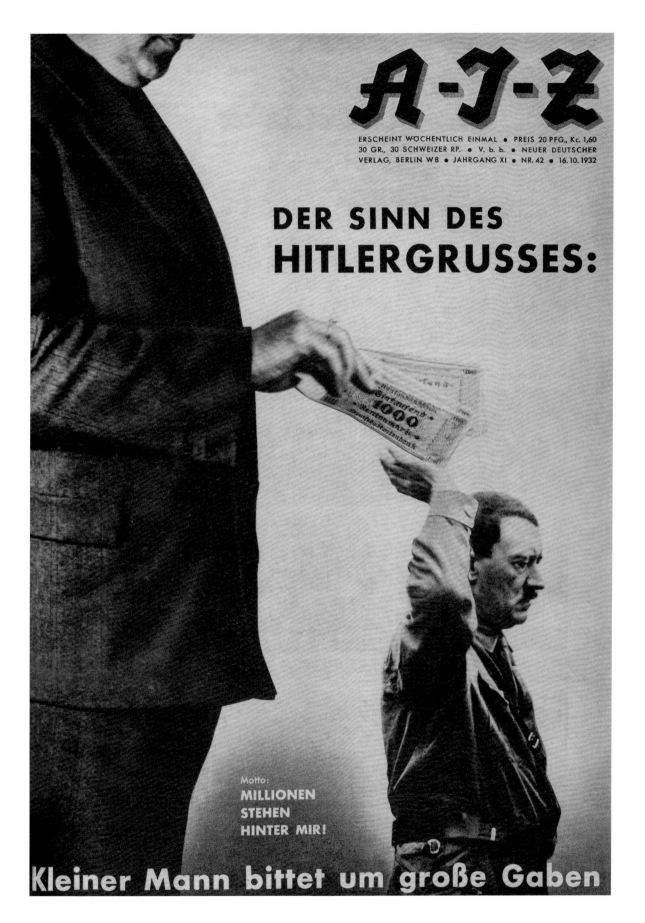

Notes

1 Kessler 1961, p. 125. / 2 Kracauer 1977, p. 315.
3 Hessel 2011, p. 232. / 4 Tucholsky 2005, vol. III,
p. 239. / 5 Best, Otto F. (ed.) 1974, p. 60.
6 Paris – Berlin 1900–1933, 1979, p. 199.
7 Die Seele, Deutsches Literaturarchiv Marbach,
Marbacher Katalog 68, 2015, p. 176.
8 Scheffler 2015, p. 222. / 9 Scheffler 1931, p. 187.
10 From "The Ballad of Mack the Knife" in
The Threepenny Opera by Bertolt Brecht and
Kurt Weill; cited here in the 1954 translation
by Mark Blitzstein.
11 Kessler 1999, p. 390. / 12 Kracauer 1977, pp. 313f.
13 Kracauer 1977, p. 313.
14 Exh. cat. Paris/Berlin 1979, p. 239.

Bibliography

Overviews, compendia, catalogues:
Gay, Peter, *Die Republik der Außenseiter. Geist
und Kultur in der Weimarer Zeit 1918–1933,*
Frankfurt am Main 1970
Best, Otto F. (ed.), *Die deutsche Literatur: Ein
Abriss in Text und Darstellung,* vol. 14: *Expres-
sionismus und Dadaismus,* Stuttgart 1974
*Paris – Berlin 1900–1933. Übereinstimmungen
und Gegensätze Frankreich – Deutschland,* exh.
cat. Centre Georges Pompidou (Paris 1978),
Munich 1979
Willett, John, *Explosion der Mitte. Kunst + Politik
1917–1933,* London 1978
Schrader, Bärbel/Schebera, Jürgen (eds.), *Kunst-
metropole Berlin 1918–1933,* Berlin and Weimar
1987
Large, David Clay, *Berlin,* New York 2000
1929 – Ein Jahr im Fokus der Zeit, exh. cat.
Literaturhaus Berlin, Berlin 2001
Metzger, Rainer, *Berlin. Die 20er Jahre,*
Vienna 2006
Beachy, Robert, *Gay Berlin. Birthplace of a
Modern Identity,* New York 2014
Bienert, Michael/Buchholz, Elke Linda, *Die
Zwanziger Jahre in Berlin. Ein Wegweiser
durch die Stadt,* Berlin 2015
Schenk, Dietmar, *Als Berlin leuchtete. Kunst und
Leben in den Zwanziger Jahren,* Stuttgart 2015
Berlin Metropolis 1918–1933, Neue Galerie exh.
cat., New York, 2015
*Tanz auf dem Vulkan. Das Berlin der Zwanziger
Jahre im Spiegel der Künste,* Stadtmuseum
exh. cat., Berlin, 2015
Berlin – Stadt der Frauen, Stadtmuseum Berlin
exh. cat., Berlin 2016

Contemporary documents:
Benjamin, Walter, *One-Way Street* in: *One-Way
Street and Other Writings,* trans. J. Underwood,
London 1979

Benjamin, Walter, *Illuminationen. Ausgewählte
Schriften 1,* Frankfurt am Main 2nd ed. 1980
Döblin, Alfred, *Berlin Alexanderplatz. The Story
of Franz Biberkopf,* trans. E. Jolas, New York 1931
Haffner, Sebastian, *Geschichte eines Deutschen.
Die Erinnerungen 1914–1933,* Munich 2002
Hessel, Franz, *Spazieren in Berlin,* Berlin 2011
Kaléko, Mascha, *Sämtliche Werke und Briefe,*
Jutta Rosenkranz (ed.), vol. 1: *Werke*; vol. 4:
Kommentar, Munich 2012
Kessler, Charles (ed.), *Berlin in Lights. The
Diaries of Count Harry Kessler (1918–1937),* ed.
and trans. Charles Kessler, New York 1999
Kracauer, Siegfried, *Die Angestellten,* Allens-
bach/Bonn 1959
Kracauer, Siegfried, *The Mass Ornament. Weimar
Essays,* trans. T. Levin, Cambridge/MA 1995
Scheffler, Karl, *Berlin – Wandlungen einer Stadt,*
Berlin 1931
Scheffler, Karl, *Berlin – ein Stadtschicksal,* Berlin
2015
Tergit, Gabriele, *Käsebier erobert den Kurfürsten-
damm,* Frankfurt am Main 2016
Tucholsky, Kurt, *Gesammelte Werke in drei
Bänden,* Reinbek 2005

Copyright

Photo credits

The editor

Rainer Metzger studied art history, history and
German literature in Munich and Augsburg. In
1994, he earned his Ph.D. on the topic of Dan
Graham, and subsequently worked as a fine arts
journalist for the Viennese newspaper *Der Stan-
dard*. He has written numerous books on art,
including volumes on Van Gogh and Chagall.
In 2004 he was appointed professor of art history
at the Academy of Fine Artsin Karlsruhe.

Imprint

**EACH AND EVERY TASCHEN BOOK
PLANTS A SEED!**
TASCHEN is a carbon neutral publisher. Each
year, we offset our annual carbon emissions with
carbon credits at the Instituto Terra, a reforestation
program in Minas Gerais, Brazil, founded by
Lélia and Sebastião Salgado. To find out more
about this ecological partnership, please check:
www.taschen.com/zerocarbon
Inspiration: unlimited. Carbon footprint: zero.

To stay informed about TASCHEN and our
upcoming titles, please subscribe to our free
magazine at *www.taschen.com/magazine*, follow
us on Instagram and Facebook, or e-mail your
questions to *contact@taschen.com*.

© 2022 TASCHEN GmbH
Hohenzollernring 53, D–50672 Köln
www.taschen.com

Project coordination: Ute Kieseyer, Cologne
Translation: Karen Williams, Rennes-le-Château

Texts: Ralf Burmeister (RB), Rainer Metzger (RM),
Maik Novotny (MN), Ulrike Zitzlsperger (UZ)

Printed in Slovakia
ISBN 978-3-8365-5050-5